The DESIGNER'S GUIDE to

GLOBAL
COLOR
COMBINATIONS

The DESIGNER'S GUIDE *to*
GL⬤BAL
COLOR
COMBINATIONS

750 Color Formulas in CMYK and RGB
From Around the World

LESLIE CABARGA





The Designer's Guide to Global Color
Combinations © 2001 by Leslie Cabarga.
Manufactured in Singapore.

Published by HOW
Design Books, an imprint of F&W Publications,
Inc., 1507 Dana Avenue, Cincinnati, Ohio,
45207. (800) 221-5831. First edition.

05 04 03 02 01 5 4 3 2 1
Library of Congress Cataloging-in-Publication Data
Cabarga, Leslie.
 The designer's guide to global color combinations :
750 color formulas in CMYK and RGB from around
the world / Leslie Cabarga.
 p. cm.
 ISBN 1-58180-195-5
 1. Graphic arts—Handbooks, manuals, etc. 2. Color
in art. 3. National characteristics in art. 4. Color com-
puter graphics. I.
Title: Global color combinations. II. Title.
NC997 .C338 2001
701'.85—dc21
 2001024574

128

0 / 100 / 84 / 0	253
	0
	21

Northern and Eastern European COLOR

Finland
Sweden
Norway
Denmark
Romania
Hungary
Czech Republic
Russia

16

0 / 20 / 100 / 0	255
	204
	0

Asian COLOR

China
Japan
Korea
Vietnam
Tibet
India
Pakistan

168

100 / 0 / 85 / 15	1
	119
	65

Middle Eastern COLOR

Iran
Palestine
Armenia

Island COLOR

152

25 / 58 / 0 / 0	187
	99
	174

Bali
Java
Hawaii
Tahiti
Haiti
Cuba
Bahamas

176
DIRECTORY

Thanks: to color consultants Marga and Anna for the sage advice and the warm nights. Thanks also to Will Ryan, Denise Hagopian, Noel Norwick, Brandel France deBravo, Mario Bravo, and all the other colorful people in the world.

Disclaimer: It was only with the greatest respect and admiration for everybody on earth that the author undertook this project, and he wishes to apologize for any factual or grammatical errors, such as sentences ending in prepositions, misplaced or neglected diacriticals, botched translations, outrageous generalizations, or any careless or off-the-cuff commentary that might be construed as offensive. In addition, every effort has been made to trace and acknowledge all copyright holders. HOW Design Books and the author would like to apologize if any credit omissions have been inadvertently made.

The color combinations from this book are available on CD rom from flashfonts.com.

[INTRO]

A designer in [SELECT LOCATION ⬍] fires up her new computer to design a spectacular [SELECT PROJECT ⬍]. She scans her mind for colors for the project, unaware of the influences her cultural heritage and personal experiences play in this selection process. The colors that spring to mind are tan and black—like the saddle blanket on her favorite yak, a pet from childhood. She contrasts these colors with a light golden color, like the steaming fresh yak milk she coaxed from recalcitrant udders on those blustery winter mornings before trekking 14 kilometers (8.7 miles) to the Jesuit mission schoolhouse with its doors of flaming red.

Another designer in [SELECT LOCATION ⬍] carries with him the imbedded color memory of the navy blue and depression-green sign urging the purchase of some now-defunct brand of motor oil at the old Flying-A station somewhere near Fulton Street that was

demolished years before Taki 183 ever raised a marker to the glossy, off-white surface of a New York subway tile.

Still another designer takes an easy color route, selecting from the 216-fits-all, Web-safe color palette. Or, meandering through the Web, she discovers a Web site that is particularly intriguing and decides to appropriate the colors straight off of it. The colors she copies could have been designed in [SELECT LOCATION ⬍] or in [SELECT LOCATION ⬍] Thus, trends in color nowadays are less "Detroit school"

or "Moscow style" than "Earth style now." Thankfully, the color police have gone the way of the KGB and Doc Marten's hightops. No one's dictating colors anymore and nobody has a clue what tomorrow's colors will be…except maybe, you.

GOOD DESIGNERS, DIRTY COLORS

The dirty little secret behind THE DESIGNER'S GUIDE TO GLOBAL COLOR COMBINATIONS is that it matters little what color combination comes from what country or era. The reason for this book is not necessarily to help you make a "French-colored" design. Even if you should want to style your work for an overseas client, it might be futile since that client probably hired you to get *your* style. The reason for this book is to open our eyes to new worlds of color and to combinations that we've perhaps never imagined before. For instance, if I'd never been to Bulgaria, I might have never heard music played in the asymmetrical 7/16 time signature that I found so fascinating, yet confounding to my Western sense of 4/4 timing.

On the other hand, if you are trying to design in imitation of a specific country, then we've certainly got what you're looking for. In general, if it works for you, any color combination you choose out of this book is as valid as any other, regardless of race, creed or…color.

AROUND THE WORLD FOR 176 PAGES

I've just returned from flying around the world and boy, are my arms tired! No, not from flapping, silly. My mouse hand is killing me, and the other arm is aching from lugging around my Macintosh G4 Powerbook (www.apple.com) retrofitted with oversized swaybars and Iskendarian racing cams (www.iskycams.com). Man, how that thing hugs the bezier curves, but it's a hard start-up on cold mornings, especially at high altitudes. I got some suspicious looks at border crossings, but it's amazing what a fistful of rupees will do to sort of smooth things over. My little souped-up traveling design studio, powered by a portable photovoltaic module (www.realgoods.com), worked swell until I hit Finland halfway through one of its four-month-long winter dark snaps and had to switch over to hydro. Fortunately, there was a dam power station nearby and they had an adapter. It was incredible to be able to rush back to my various hotel rooms with arms full of local candy wrappers, magazines, books, menus, prints, clothing items and all manner of printed ephemera and what-nots, and then input the colors of the place while still in its milieu.

GIVE PUCE A CHANCE

The experiences I had on my world voyage and the people I encountered, from Manhattan to Madagascar to Malmö, will remain

The author in search of color: in Egypt at the tail end of the Sphinx; checking colors in India at the Taj Mahal; clowning in Italy at the Leaning Tower; checking colors in China at the Great Wall.

DEADLY COLOR

Trauma Coral	0/55/61/0	252
		116
		72
Putre-Taupe	36/38/62/20	130
		107
		65
Black	63/52/50/100	0
		0
		0
Livor Lavender	28/45/6/3	178
		124
		174
Adipic Gold	3/40/76/0	246
		151
		50
Livor Verdigris	61/25/66/35	65
		91
		54
Livor Gray	51/29/39/15	107
		122
		109
Trauma Red	10/87/100/3	225
		32
		7
Cadaver Yellow	5/16/51/0	238
		207
		114
Cavity Maroon	31/85/85/53	82
		16
		12
Viscera Cyan	70/7/20/0	77
		170
		172

EXHAUSTIVE STUDY OF PHOTOGRAPHS OF ACCIDENT VICTIMS AND CADAVERS, LED DESIGNER DAVID LINCOLN BROOKS TO DEVELOP THIS DEADLY COLOR PALETTE OF BODY PARTS IN VARIOUS STATES OF DECOMPOSITION. TIME AND AGAIN, HE WAS ABLE TO CORROBORATE THAT SIMILAR STATES OF BODY MORBIDITY IN DIFFERENT SUBJECTS YIELDED IDENTICAL COLORS. THE PALETTE PRODUCES A DISTURBING VISCERAL REACTION —IT IS MILDY SICKENING—LENDING CREDENCE TO HIS CLAIM OF AUTHENTICITY.

1. Trauma Coral: color of skin surrounding a stab wound.
2. Putre-Taupe: mushroomy color of skin and tissues in advanced putrefaction; the last color before turning black.
3. Black: color of total and utter putrefaction of human tissues.
4. Livor Lavender: color of very early putrefaction seen one to two days after death.
5. Adipic Gold: color of human fat immediately under the skin, and surrounding the viscera.
6. Livor Verdigris: gray-green of livor mortis; the color of skin in advanced putrefaction.
7. Livor Gray: blue-gray of earliest livor mortis, occuring before livor verdigris, above.
8. Trauma Red: the color of fresh, oxygenated blood.
9. Cadaver Yellow: human skin after the blood has left it.
10. Cavity Maroon: the color of unoxygenated blood and tissue deep within the body cavity.
11. Viscera Cyan: the amazing (basic) color of healthy human lungs and intestines.

fond memories even long after I'm too old to remember anything. As an American, it's too easy to forget that we enjoy the world's highest standard of living, after Kuwait. It takes an experience like the one I had high up in the Verkhoyansk mountain range of Central Siberia to remind me that not everyone has a 21-inch (53.3-centimeter) color monitor at home, as I have. In a small waddle-and-daub hut, huddled together with several farm animals to keep us warm, my hosts Dudinka and Potapovo proudly displayed the small, MS-DOS-era computer and green-screen monitor with which they surfed the Net looking for porno. Painstakingly, they had created dozens of transparent screen overlays consisting of hand-cut bits of colored cellophane to correspond to the images found on their favorite sites, thereby introducing a dash of color into their humdrum lives. *This is how important color is to people!*

In Bali—one of the few places I found, besides Tibet, where people seem to live their religion by example and not by rote—I was gratified by the willingness of many Balinese to whisk off their sarongs so I might make scans (www.microtek.com), in situ, from these multicolored marvels of the batiker's art. Everywhere I went, I was touched by the humanity of the people I met and by their willingness to share colors and/or a meal with me, a perfect stranger. Vast cultural differences, lack of ability to communicate well and resentments over past American military adventures (to make the world safe for Exxon, Coca Cola and Marlboro) seemed to melt away into irrelevancy as we sat peacefully together, crosslegged on a profusion of hand-loomed rugs, drinking coffee so strong it would melt titanium. For hours, my hosts patiently indulged me while I asked such probing questions as, "Okay, so like, why green?"

Time and again I had pause to reflect upon the words of Dwight D. Eisenhower who once said, "People want peace so much that one of these days governments had better get out of the way and let them have it."

IF IT'S TUESDAY THIS MUST BE MAGENTA

Having spent eighteen months traversing the globe collecting color samples from over forty-eight countries, I can truly say the book you are holding in your hands is a colossal failure. How could it be otherwise? It would take many years and thou-

sands of pages, at the very least, to begin to do justice to the subject; to truly, accurately and completely summarize indigenous color trends from every corner of the globe. I feel almost heartbroken as I recall the endless combinations of amazing colors I encountered and the hopelessness of attempting to present them thoroughly. Just as I was really getting into a country's colors, I'd run out of pages and have to hop on yet another plane. My final color choices were based upon only the most critical and objective criteria: Whenever I encountered a color scheme that made me say "Wow!" it made the cut. Ultimately, the higher-profile countries—Japan, France, China, Russia—are better represented in this book than other lesser-known (at least to Americans) countries. Hopefully, my readers will not infer any preferential biases in my selection of certain countries over others.

The contents of this book evolved something like that famous sign **PLAN AHEAD** as I got carried away in the earlier chapters and had to cut back on later ones. The colors of the African continent alone would have filled this book and still yielded combinations every bit as diverse as the book presently has. The real reasons certain countries were omitted are that flights to more popular airports are generally cheaper, the typical price of a camel caravan has risen steeply (thanks to GATT and MTV) and publishing budgets aren't what they used to be. Apologies to the designers of Qatar, Palau, Djibouti, Maldives, Tuvalu, Liechtenstein, etc., for missing your countries. And there were many other, less obscure nations that I, with reluctance, was forced to omit. One *very large, northern country* in particular couldn't get its act together in time to make my deadline. It would be imprudent to mention its name, but suffice it to say, your prime minister will be hearing "aboot" it, eh?

The Designer's Guide's inadequacies aside, there are enough color combinations here to keep us all busy until the final book in the trilogy (*The Designer's Guide to Intergalactic Color Combinations*) is eventually released (encoded hologramistically on pure methane effluvia).

IT'S A MALL WORLD, AFTER ALL

Today, ever-expanding "world trade" and the "global marketplace" translate to a search for the next "sucker." That is, untapped markets of naïve customers just aching for the

CAMOUFLAGE
COLOR

COLORS TAKEN FROM A CAMOUFLAGE MANUAL. THIS PALETTE IS USEFUL FOR PROTECTING YOUR GRAPHIC DESIGN FROM SNIPERS IN A HOSTILE FOREST ENVIRONMENT. THESE COLORS ARE NOT RECOMMENDED FOR PRODUCING EYE-CATCHING LAYOUTS (SEE ABOVE).

30 / 40 / 100 / 30	126
	92
light green	6
70 / 40 / 100 / 50	38
	51
dark green	11
0 / 40 / 70 / 20	203
	123
sand	49
10 / 35 / 60 / 25	171
	119
field drab	63
60 / 90 / 100 / 15	87
	16
earth brown	1
0 / 50 / 85 / 20	203
	102
earth yellow	23
71 / 94 / 100 / 30	52
	9
loam	1
40 / 80 / 90 / 0	153
	42
earth red	19
45 / 56 / 100 / 30	98
	62
olive drab	7

SIGNALGRAU FARBE
Bonus Palette 3

Signalgrau's Dirk Uhlenbrock indulged us in a little free association by coming up with some personal favorite colors and their significance. The CMY skull logo, left, and the bull, below, are examples of Dirk's clever spot art. More of Signalgrau's work can be found on pages 86 and 87.

opportunity to purchase products they've never heard of before, can barely afford, and now can't live without. I'm reminded of the two-roomed, mud-floored home I visited in Indonesia in which the enshrined photo of General Suharto vied for attention with the new television set. The homeowner complained about his youngest son, who refused to work the rice fields as the family had for millennia and instead spent his time watching soap operas, commercials and rock videos. But how ya gonna keep 'em down on the farm, to paraphrase an old song, after they've seen TV?

The positive side to declining trade barriers—the media explosion and the Internet—is the resulting exposure to new ideas, new methods and even new colors—at least for those fortunate enough to be plugged in. That is why modern design from Pakistan, for example, doesn't look much different than contemporary designs from any other part of the world. The Pakistani designer may have been inspired by a Ukrainian Web site he visited or a French magazine he read. I personally hope that the information age will bring not just news of the latest items for purchase, but greater awareness of the insidiousness of government and corporate propaganda, which have increasingly become so inseparable.

Because of the current melting pot of global design, I selected many color combinations from the past. These can be more representative of a particular country's traditional color taste than newer works, which may have been influenced by the design of American CD covers. Old-fashioned colors are no less useful, anyhow. There is a current trend among many designers toward the muted, subtler, grayed-down colors such as those used in olden times. Resurrected in modern layouts, they can convey a richness and elegance and lend a feeling of long-established importance to our designs. When breaking down ancient and modern designs for their colors, I was often surprised that, in many countries, great similarities existed between the old and new.

Color Palettes

Elvis
CMYK	R	G	B
0/0/0/100	0	0	0
0/41/4/0	249	153	195

50s C and M
CMYK	R	G	B
100/0/0/0	0	160	198
0/100/0/0	240	2	127

Summer Day
CMYK	R	G	B
3/39/94/0	247	154	16
0/20/94/0	255	204	17

Tintin
CMYK	R	G	B
40/5/11/0	153	205	204
28/94/54/16	152	15	51

Bauhaus
CMYK	R	G	B
16/95/95/4	203	16	9
0/0/0/0	255	255	255

Forest Weekend
CMYK	R	G	B
39/5/11/0	155	204	203
93/26/46/11	20	102	102
19/30/77/6	194	154	50

Baby Blues
CMYK	R	G	B
4/0/20/0	245	251	203
0/20/11/0	252	205	204
19/15/0/0	206	203	227

Retro Chic
CMYK	R	G	B
19/11/81/0	207	207	52
40/5/36/0	153	207	152
35/24/50/8	153	153	103

Bottom row
CMYK	R	G	B
16/33/94/4	205	152	19
19/12/58/0	206	207	103
19/12/34/0	207	207	155
16/62/93/4	205	87	16
18/79/93/4	199	48	13
29/39/93/4	173	129	23
40/14/31/8	141	170	143

HOW TO USE THIS BOOK

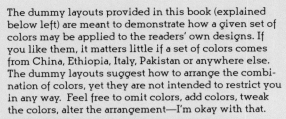

The dummy layouts provided in this book (explained below left) are meant to demonstrate how a given set of colors may be applied to the readers' own designs. If you like them, it matters little if a set of colors comes from China, Ethiopia, Italy, Pakistan or anywhere else. The dummy layouts suggest how to arrange the combination of colors, yet they are not intended to restrict you in any way. Feel free to omit colors, add colors, tweak the colors, alter the arrangement—I'm okay with that.

In this book you will not find complex theories of color harmony, or formulas for achieving perfect color complements. This is a color swipe file, providing some of the world's most interesting color combinations for you to steal. The difference between this and most other color swatch books is that accompanying all of the swatch sets are simple, dummy layouts that suggest *how* to use the swatches.

You'll see which colors to use on typical design elements such as type, drop shadows, backgrounds, boxes for additional type and sidebars, and borders and accents. The dummy layouts suggest how to accentuate certain colors and subordinate others to achieve a certain effect. The point of the dummy layouts is to show that it's not only about *which* colors you choose, but also about how the colors are arranged that makes the design successful. You are free, of course, to shuffle, add, subtract and tweak the color examples to your heart's content. The only rule is that there are no rules in color usage. It's whatever feels right.

HOW THIS BOOK IS ARRANGED

Each page contains one provocatively-colored design example from the subject country. Below it are two dummy layouts displaying colors selected from the design. In the layout on the left, the colors are placed in an hierarchical arrangement similar to that of the design. The designs were frequently too complex to allow perfect imitation and many were *too colorful*, so only the eight most important colors were selected for the swatches.

CHAKRAS & MUSIC

	25 / 58 / 0 / 0	187
Crown		99
		174
	55 / 55 / 0 / 0	117
Brow		93
		170
	77 / 20 / 14 / 0	62
Throat		144
		171
	64 / 0 / 100 / 0	92
Heart		179
		35
	0 / 20 / 100 / 0	255
Solar Plexus		204
		0
	0 / 59 / 100 / 0	255
Sacral		105
		0
	0 / 100 / 84 / 0	253
Root		0
		21

All things are profoundly interelated. So are music and color and the energy centers of the body known in Eastern religion as the chakra system. This explains why so many musicians are also artists and why most artists are also usually musicians. In fact, many of today's designers use music as a key source of inspiration.

In the second layout, the colors are arranged in a completely different way to demonstrate how this can totally alter the feeling of a design.

In the center of each spread are eight dummy layouts with colors derived from other sources from each subject country. The color sources for these include: fabrics, posters, advertisements, tiles, Web sites, ceramics, rave flyers, signage, packaging labels and myriad other items that I discovered on my color trip around the world. Though these additional layouts are mostly unattributed, they combine to form an eclectic, though hopefully faithful, representation of the colors and tastes of each country.

As you search for appropriate color combinations through the many pages of dummy layouts in this book, I suggest you try to look at each layout individually. Otherwise, you might reject a viable color combination due to the influence of neighboring schemes. You can avoid this problem by cutting a 2-inch (5-centimeter), by 2.25-inch (7-centimeter) hole out of a piece of white and/or black paper in order to "mask out" the rest of the page.

If music were color, what colors would it be? If nations were colors, what color would each nation be? What colors are artists? Decades of the twentieth century? The following are my purely personal opinions on this topic. Note: The lists are not intended to relate to one another.

AUSTRALIA	MICHELANGELO	1960s	1990s	THE BEATLES	
AFRICA	REMBRANDT	1890s		MOZART	
No. AMERICA	MAXFIELD PARRISH	1940s		DUKE ELLINGTON	
EUROPE	PAUL KLEE	1910s	1930s	BILL MONROE	
ASIA	JOAN MIRÓ	1900s		GEORGE JONES	
South AMERICA	ALFONS MUCHA	1920s	1970s	EDITH PIAF	
Eastern EUROPE	FRIDA KAHLO	1980s	1950s	MIRIAM MAKEBA	

CMYK	RGB		CMYK	RGB		CMYK	RGB		CMYK	RGB		CMYK	RGB
32 97 100 **32**	117 7 0		0 79 100 **72**	71 15 0		100 69 0 **11**	12 45 131		0 87 16 **55**	85 13 42		100 0 51 **43**	0 84 71
0 91 94 **30**	178 17 7		26 54 80 **20**	151 83 33		70 19 0 **0**	79 154 198		39 90 28 **11**	138 21 88		71 0 68 **31**	50 120 66
3 45 37 **3**	235 135 20		16 45 55 **6**	200 123 84		20 8 0 **0**	204 218 234		28 70 10 **0**	181 71 145		43 0 85 **20**	116 164 44
			10 20 30 **0**	228 197 159					10 30 0 **8**	209 160 196		25 0 50 **10**	172 206 114

POLY-MONO-TONE

Four-color printing is becoming the standard, even for "cheap" jobs like newspapers and business cards. For those who miss one- and two-color printing, here are Jean Tuttle's suggestions as to how you can capture (and punch up) the look of old, limited-color, monotone printing in today's glorious polychrome publishing environment.

WEB-SAFE FOR YOUR PROTECTION

Web publishing takes publishing out of the hands of printing firms and gives us illuminated manuscripts every time by virtue of our color monitors. Our only concern, then, is whether other people's monitors will display our colors exactly as we've created them.

For this reason, the 216 Web-safe colors were invented by somebody. I don't believe in Velveeta cheese, fluoride toothpaste or Web-safe colors. The Pantone Matching System (containing thousands of printing ink colors) has been around for thirty years and very few of their colors are nice, yet here comes the Web-safe palette and it's full of beautiful colors. One could almost stay with Web-safe colors and be a happy designer. Either the Web-safe developers tapped into some sacred geometry of color to achieve such a lovely spectrum, or it's all a ruse. I do believe that there is a universal relationship of colors to numbers, musical notes, the chakras and even astrology. I once had a dream in which my hands were poised over my piano keyboard while another hand pointed out the relationship of musical notes to color. When I awoke, I forgot the whole thing.

Of course, there are ugly colors among the 216, too. (Go to any amateur Web site.) And there are, of course, many ugly ways to combine otherwise attractive colors from the Web-safe palette (and "ugly" is subjective). Web-safe colors are advocated because many people are still using older monitors on which colors other than Web-safe ones may not reproduce well. But on older, cheaper monitors, *all* colors the user sees—not just web colors—will look pixelated.

I suggest that using Web-safe colors isn't necessary. Whether your monitor is high-end or low-end, no two monitors will display colors the same anyway, so no designer is guaranteed that his vision will survive the Web. But more importantly, I believe that however our colors end up, other computer users will never know the difference. That's why there are no Web-safe colors specified in this book. That and because it would have been too much work. If you insist on being Web-safe, many programs like Adobe Photoshop and Macromedia Flash will snap colors to Web-safe (though that will cause most colors to radically change).

SEE, EM? WHY, KAY!

Sitting on a mountain in Brazil, high above the din of buzz saws hacking down precious rain forest, I had an epiphany. Why must CMYK percentages always be listed as 10, 20, 30, and so on? Percentages like 11, 22,

1. Lines, lines, lines.

2. Lines and rounded-corner boxes.

3. Type within lines, grids & rounded-corner boxes.

4. Wire frame and spirally whirls

5. Profusion of meaningless lines, boxes, arrows, numbers etc., etc.

HOW TO BE A GRAPHIC DESIGNER!

People are always e-mailing me the question: "Mr. Cabarga, how can I stay current with modern design trends and become a big-time designer like yourself?" After making some obligatorily self-effacing statement and taking a credit card number, I usually send out the following twenty essentials—the only twenty design tips you'll need to become a hip and edgy designer, like everybody else. Pay attention, take notes and have fun. Remember, in 2010, when we look back at rounded-corner boxes and blurry backgrounds, we'll all shudder and want to puke.

and 33 are faster to type. For that matter, 9 percent is easier for users to key in than 10 percent. The difference of one or two percentage points can hardly matter. There's always a plus/minus 5 to 10 percent ink density factor in commercial printing anyway, and the inconsistencies of color monitors has been adequately covered here.

In precomputer days, print shop cameramen were stuck with halftone screens in increments of 10 percent. Now we can key in any weird percentage we want. After all, RGB formulations are without rhyme or reason and are completely counterintuitive. Since when did mixing red and green make yellow? *Note:* just as color intensity can noticeably diminish when converting an RGB image to CMYK, the RGB formulas in this book will appear somewhat brighter when typed into an Adobe Photoshop RGB file.

Despite certain limitations of CMYK—the cyan, magenta, yellow and K for black process color inks used in most four-color printing—working on this book has made me newly appreciative of the system's versatility. Admittedly, some colors like fluorescent green, certain shades of light or bright orange and many kinds of blue cannot be captured well in CMYK. Otherwise, CMYK does a good job, especially when we are not limited to rounded-off percentages in tens, as mentioned earlier.

In selecting individual colors for the combinations in this book, I first looked for designs with an evenly stepped spectrum of light-to-dark colors. This usually allows good contrast between colors, enabling almost any two to touch without seeming to visually blend. Contrast between colors allows for legibility when type is placed in a design. When colors were too close together in value, I used the standard designer's

11. Fat-stroke ellipse tool grafix requiring no drawing skill.

12. Glowing outlines and pop-art halftone dot halos.

13. Big dot comic blowups.

14. Anything indecipherably Asian.

15. Graffiti, "tribal" and fuzzy black drop shadows.

6. Blurry montage backgrounds.

7. Blurry montage backgrounds and distressed clip art!

8. Blurry montage backgrounds and circuit boards.

9. Blurry montage backgrounds of old schematical diagrams.

10. 3-D rendering!

trick of placing a drop shadow or outline around the type to set it apart from the background.

Occasionally you will find bright, simple CMYK colors in this book such as 0/100/100/0 or 50/0/100/0, but most color swatches contain small amounts of the remaining colors thrown in to jazz them up. For example, 15/88/100/5 or 50/22/100/3 are much more interesting colors than the first formulas. It's often incredible how a little bit of added yellow will bring a whole new emotional charge to a medium gray. And anyway, I just spec them as I find them. Most designers and artists the world over appear to prefer their colors more muted and complex rather than pure and bright. A common technique—and a very effective one—is to let darker or muted colors predominate in a design, then throw in a couple of pure and simple bright colors to accent the type or a central image. The opposite approach works well too.

IN SUM

I've described *The Designer's Guide to Global Color Combinations* and the first *Designer's Guide to Color Combinations* (North Light Books, 1999), as "the books I've needed all my life." I made them to help me with my work—and you can use them, too. However, the Designer's Guides are not guidebooks to the future, but merely a chronicle of what was, up until the moment page 176 wrapped. I think of those immortal words of Plato (whose country I couldn't fit in the book, either): "Επειδὴ φωεῖω ἄπειρον κατενόησεν εἴτὲ τις Θεὸς εἴτέ καὶ Θεος Ανθρωπ℗." But your color combinations will not be mired in anachronism. Yours will be of tomorrow; a tomorrow Plato could only dream of. I've taken you from crayons to perfume, and back to crayons again. Now go—and do me proud!

—Leslie Cabarga

16. Bitmap, sliced, schizo, horizontal-scaled, negative-leaded fonts and groovy freeware fonts.

17. Girls, girls, girls.

18. Posterized girls, 72 dpi lo-rez pixelated RGB girls and grid girls.

19. Out-of-register, CMYK swatchblock girls.

20. Chaos.

Downtown Frankfurt does not look a whole lot different than Queens, New York, or parts of Paris, Oslo, Manchester or Cape Town. But when you're in Hangzhou, Karachi, or even in Yokahama, you know you're not in Kansas anymore, Tojo! This is what thrilled me about traveling throughout Asia and being exposed to cultures and colors so vastly different than my own. ■ The pink and light green so popular in China and India may simply be a time lag issue. Since ancient Asian colors are generally muted and sophisticated, I surmise that these two countries were influenced by American colors of the 1950s and never got past them. Chinese clip art also looks suspiciously like 1950s design. China's young designers, however, are as hip as any. ■ With their love of iconography and design for its own sake, the Japanese have had a profound influence on world design. Japanese colors are *what's happening now* and are admired by designers the world over. ■ Koreans love unsubtlety, especially in their traditional garb. They freely

mix and match the wildest, most fluorescent colors and amazingly, it works! ■ Over in Pakistan, despite the presence of a restrictive government, things are hopping. Bars and discos are illegal. No matter—"house parties" of 500 to 1,500 people are common, and modern Pakistani design looks like the best New York has to offer. ■ I was greeted with some initial trepidation by the people of Tibet. After a few Tibetans heard of my mission, I was ushered into a sacred chamber and proudly shown a tattered PMS book, its chips badly faded with age, even though Pantone recommends upgrading your swatch books every couple of years to ensure accurate color-matching. ■ Asian color schemes, though somewhat unusual to our Western eyes, are always fascinating and highly useful.

0 75 75 **10**		228 59 36	
100 40 18 **0**		6 94 144	
0 10 40 **0**		254 230 146	
0 37 40 **7**		234 150 116	
30 30 5 **3**		172 155 189	
40 0 0 **100**		0 0 0	

100 15 100 **0**		0 116 47	
17 5 100 **0**		212 223 9	
0 40 25 **3**		243 149 148	
0 85 50 **10**		224 37 66	
10 10 10 **10**		255 140 0	
40 0 0 **100**		0 0 0	
White		255 255 255	

DECORATIVE GOOD LUCK PIECE This bit of embroidered Chinese chachkis, like the paper cutout opposite, is used as a decoration to attract good luck. The color scheme, despite its lack of warmth, is richly elegant and seems typical of a certain classical Chinese aesthetic. Depending on their taste in color, a few of these dreary pieces around the house might indeed keep the invading Mongol hordes from the door.

8 62 53 **0**		231 95 33	
0 75 80 **0**		253 65 32	
55 23 62 **23**		89 115 70	
73 27 3 **0**		73 135 184	

25 13 13 **6**		179 189 186	
40 60 63 **54**		70 39 31	
0 31 15 **0**		251 177 183	
0 6 11 **0**		254 240 220	

100 30 50 **0**		2 104 107	
10 5 100 **0**		230 231 4	
50 50 0 **0**		152 131 190	
100 30 0 **0**		5 113 176	
7 40 0 **0**		232 150 201	
13 100 0 **0**		211 2 127	
50 0 50 **10**		114 181 114	

0 30 30 **5**		239 171 144	
10 45 50 **10**		205 122 89	
5 7 5 **0**		241 233 231	
0 55 60 **0**		252 116 74	
55 77 5 **15**		97 38 5	
10 80 33 **15**		190 43 87	

25 7 0 **0**		191 215 233	
44 11 60 **0**		143 184 100	
55 44 33 **0**		116 112 127	
66 88 88 **0**		87 22 20	
22 66 66 **0**		197 80 59	

0 20 100 **0**		254 204 54	
5 50 22 **0**		237 126 148	
10 66 88 **0**		229 84 33	
33 66 100 33		114 49 2	
0 88 40 **20**		198 27 68	
45 45 0 **0**		140 118 183	

11 11 33 **15**		192 185 136	
66 33 44 **0**		88 125 116	
88 55 66 **0**		34 71 69	
44 66 66 15		121 60 51	
100 77 55 **0**		7 34 71	

10 7 0 **0**		229 229 241	
7 100 88 **0**		235 0 16	
83 85 0 **0**		54 28 137	
7 33 100 **0**		237 166 29	
40 0 0 **100**		0 0 0	

GOOD LUCK PAPER CUT These incredibly colorful and meticu-lous cut outs are generally used as window decorations. They are hand cut using tiny scissors and knives, and then painted in watercolors. Other small subjects include Chinese astrological characters. The art of the paper cutout also includes more elaborate, large-scale pieces suitable for framing. Colors tend toward the cheerful and unsubtle.

15 100 60 **0**		213 0 51	
60 65 10 3		102 68 140	
0 4 90 **0**		255 245 25	
0 77 75 **0**		252 40 37	

63 0 53 5		89 177 115	
40 25 S 14		131 133 14	
70 0 10 **0**		76 186 198	
40 0 0 **100**		0 0 0	

LAN ZHOU
TRADE MARK
MIN SHAN BRAND

龍膽瀉甘丸

CHINESE HERB MIXTURE
CHINESISCH KRAUT GEMISCH
CHINO HIERBA MEZCLA
CHINOIS HERBE MELANCE
CINESE ERBARIO MISTURA

歷　史　名　方
選　材　地　道
工　藝　精　良
質　量　上　乘

MEDICINE PACKAGE They don't always need lab tests, the
Chinese. Stick out your tongue and extend your wrist for
an ample diagnosis. Then you may be sent away with bags
of herbs to make a restorative tea or a few bottles of pills
wrapped in a cautiously cheerful package like this. When it
comes to medicine and color, one billion Chinese can't be
wrong.

15 31 62 **15**		184 140 71
60 0 11 **4**		99 189 192
50 0 60 **0**		127 200 107
0 93 60 **0**		249 22 54

40 0 0 **100**		0 0 0
White		255 255 255

0 80 75 **20**		202 40 31
5 25 0 **20**		190 151 176
70 35 0 **10**		71 111 165
0 20 15 **3**		242 198 189
20 0 20 **10**		184 212 178
0 5 20 **3**		244 233 192
25 30 75 **20**		175 149 109
40 0 0 **100**		0 0 0

60 20 5 **10**		93 143 174
90 25 0 **10**		26 114 166
83 85 0 **0**		54 28 137
20 10 5 **0**		203 213 221
80 0 70 **20**		40 132 75
0 100 30 **0**		245 1 89
0 0 80 **0**		255 255 51

0 35 100 **0**		255 166 0
0 75 80 **0**		253 65 32
40 50 0 **15**		129 93 152
80 50 0 **30**		38 63 117
85 5 20 **30**		23 80 85
40 0 0 **100**		0 0 0

0 50 20 **0**		249 129 153
10 70 70 **0**		120 220 100
88 35 45 **22**		120 220 100
75 0 30 **10**		58 161 145
90 35 45 **65**		120 220 100

100 44 44 **40**	2 48 61
66 75 22 **7**	85 44 109
20 30 0 **10**	181 150 187
70 5 15 **0**	77 176 184
White	255 255 255

10 7 17 **0**	229 230 201
17 30 15 **0**	210 168 180
5 20 60 **0**	241 200 95
5 45 80 **0**	241 137 40
60 0 30 **30**	72 136 116
70 70 60 **30**	55 38 47
White	255 255 255

0 15 50 **0**	254 217 118
50 20 0 **0**	127 166 206
15 87 90 **0**	216 32 15
10 22 40 **20**	203 164 110
0 50 100 **10**	230 115 0
100 60 40 **30**	3 43 71

70 7 15 **0**	77 173 184
100 50 0 **0**	8 96 168
35 65 0 **10**	148 72 148
0 40 60 **15**	215 131 69
40 40 10 **0**	150 130 172
0 5 30 **0**	255 242 174
40 0 0 **100**	0 0 0

MEDICINE PACKAGE The color feeling and design of these packages bring to mind an Asian version of American cigarette packages from the 1950s. There's a similar attempt to create the appearance of respectability and time-honored integrity. This just goes to show what one can pull off merely with design, regardless of the type of product or its point of origin.

0 57 73 **0**	253 111 50	0 91 75 **0**	252 25 35
67 91 100 **0**	84 17 2	White	255 255 255
0 6 50 **0**	255 240 123		
36 34 75 **3**	158 137 58		

1999.12.20

POSTER DESIGN Zheng Chao, designer. In 1999, after 100 years as a Portuguese colony, the city of Macau was returned to China. This poster compares the mouth positions used in the now-preferred Chinese pronunciation of Macau rather than the despised Portuguese one. Though the style of her design brings to mind Chinese Warhol, Chao's colors are almost militantly nationalistic. Which is cool, I mean.

85 20 58 **0**		0 146 **127**
0 8 93 **0**		248 231 **2**
0 90 100 **3**		219 61 **34**
40 0 0 **100**		0 0 **0**

80 30 3 **0**		55 126 **179**
15 0 0 **0**		217 241 **247**
0 55 55 **5**		239 110 **79**
30 20 0 **0**		178 182 **216**

40 0 80 **10**		145 199 **61**
77 0 44 **5**		57 165 **130**
60 0 70 **30**		72 132 **63**
0 60 0 **0**		246 104 **178**
0 25 0 **0**		251 192 **223**
10 0 100 **0**		230 243 **4**
40 0 0 **100**		0 0 **0**

70 0 60 **20**		62 143 **87**
35 60 0 **15**		140 77 **144**
60 40 0 **5**		99 114 **173**
5 30 45 **0**		227 135 **108**
0 0 25 **80**		51 51 **38**

0 30 70 **10**		229 162 **59**
70 30 0 **0**		80 133 **188**
20 30 40 **30**		152 123 **96**
40 0 0 **100**		0 0 **0**
White		255 255 **255**

0 100 60 0		249 0 51
0 0 70 0		255 255 77
100 80 0 10		14 30 125
40 0 0 100		0 0 0
White		255 255 255

90 0 40 20		62 146 116
0 50 85 0		254 127 29
0 0 85 0		255 255 39
0 85 85 0		253 40 22
64 64 0 15		82 61 135

0 50 0 0		247 129 191
80 60 0 0		59 73 159
70 80 S 15		65 29 6
0 35 60 0		253 167 84
0 3 30 3		247 239 171

0 0 55 0		255 255 115
0 10 100 5		242 218 0
30 0 40 0		179 224 149
65 0 65 5		85 174 94
85 0 35 0		26 113 134
85 50 0 35		46 87 165

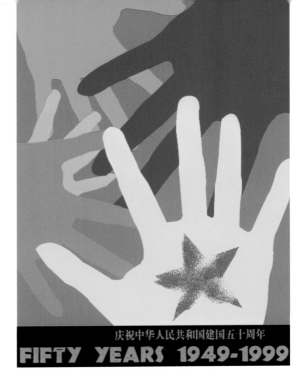

POSTER DESIGN Zheng Chao, designer. This poster commemorates the 50th anniversary of the People's Republic of China. The title of the piece, *Wuxing*, means "five stars" as found in the Chinese flag. The colorful image seems to indicate China's growing openness toward the global community and its inevitable embracing of all cultures—even, apparently, of the blue and green races.

100 75 0 3		48 67 148		60 0 90 0		96 189 67
6 90 0 0		219 35 131		0 8 95 0		248 231 2
0 55 90 0		237 144 29		40 0 0 100		0 0 0
7 85 100 5		207 65 33				

58 41 11 **5**		104 111 156	
100 36 0 **55**		2 46 77	
14 60 100 **7**		203 86 1	
13 21 63 **6**		208 179 80	
11 9 19 **0**		226 222 194	

17 19 25 **0**		211 193 169	
38 54 56 **0**		157 99 82	
62 31 62 **0**		97 129 86	
0 90 60 **18**		205 23 46	
50 33 0 **0**		128 141 194	

DRAGON COVER DESIGN In ancient China, dragons did not breathe fire. Dragons were wise and caring. They guarded the wind, the rain, the rivers, precious metals and gems. The dragon is the supreme spiritual power, the most ancient emblem in Oriental mythology and the most ubiquitous motif in Oriental art. And they come in many varieties, such as this four-legged, equine version.

38 19 67 **35**		103 12 53	
4 43 29 **0**		241 144 141	
12 86 87 **4**		214 34 19	
33 19 39 **18**		140 147 113	

14 39 63 **7**		202 137 71	
5 11 18 **0**		241 223 196	
40 0 0 **100**		0 0 0	

14 23 100 **22**		171 143 3	
18 70 100 **15**		178 60 1	
44 55 11 **5**		136 94 148	
78 94 19 **24**		49 10 80	
White		255 255 255	

12 34 100 **14**		192 136 2	
28 52 100 **14**		158 91 5	
14 11 87 **5**		209 20 135	
8 90 34 **18**		187 23 75	
100 50 0 **21**		8 63 127	
White		255 255 255	

51 17 37 **0**			126 168 141	
0 77 100 **0**			255 60 0	
60 57 0 **13**			92 75 145	
26 35 0 **9**			170 136 182	
5 12 0 **0**			241 220 235	

50 100 60 **0**			128 0 50	
75 32 0 **0**			68 126 185	
10 44 0 **0**			225 139 196	
100 36 0 **55**			2 46 77	
42 17 25 **0**			148 177 165	
10 4 6 **0**			230 236 230	

0 70 100 **0**			255 74 0	
0 70 100 **27**			186 54 0	
14 23 100 **22**			171 143 3	
8 10 80 **0**			235 222 51	
White			255 255 255	

15 5 30 **0**			217 228 171	
14 23 100 **22**			171 143 3	
74 50 100 **0**			66 83 20	
40 0 0 **100**			0 0 0	

DRAGON DESIGN In traditional Chinese New Year's Day parades, the dragon is believed to repel evil spirits that would otherwise spoil the new year. The snakelike dragon above, c. 1930, is but one of the Chinese dragon's many incarnations (see opposite). Our first color swatch, below, stands in for the gold ink used in the original print, above.

13 46 93 **3**		215 126 18		0 18 100 **0**		255 209 0
73 47 16 **33**		49 65 99		55 24 82 **31**		80 101 38
45 0 49 **3**		136 200 125		23 86 100 **7**		182 31 0
0 0 42 **0**		255 255 148				

FA TIAO

啄木鸟

ZHUOMUNIAO

ZHUOMUNIAO

—— 啄末鸟

TOY BOX Somehow, time has mercifully ignored the humble factories producing simple toys like the pressed-tin, windup woodpecker found within the cheery packaging above. Without the joysticks, LCD screens, talking pull-strings or even batteries of their contemporaries, toys like these continue to delight. The seven-color letterpress-printed box is at least as fascinating as the woodpecker inside.

C	M	Y	K		R	G	B
0	0	45	0		255	248	165
50	3	58	0		129	198	110
34	26	71	9		153	146	64
5	60	95	0		241	100	13

C	M	Y	K		R	G	B
80	4	0	0		52	173	207
0	87	100	0		255	34	0
40	0	0	100		0	0	0
White					255	255	255

C	M	Y	K		R	G	B
0	0	70	0		255	255	77
5	50	0	0		235	127	189
80	0	20	5		49	166	167
33	73	0	0		168	53	156
7	90	100	7		220	23	0
70	0	100	3		0	136	55
100	66	33	0		9	52	106
42	0	0	0		149	215	231

C	M	Y	K		R	G	B
0	0	70	0		255	255	77
0	62	77	0		253	98	41
70	90	100	7		220	23	0
0	33	44	0		252	172	119
34	30	15	0		167	154	173
77	88	0	0		69	24	135
100	0	100	0		0	136	55

C	M	Y	K		R	G	B
15	25	25	5		204	171	155
0	15	5	0		253	217	224
70	5	15	10		71	159	167
10	40	50	25		170	110	76
0	65	80	0		253	90	34
10	10	10	10		102	26	28

C	M	Y	K		R	G	B
57	36	0	0		111	129	187
83	84	34	27		37	20	67
14	14	40	0		218	207	138
53	33	63	17		100	110	69
92	22	52	8		22	112	101

C	M	Y	K		R	G	B
0	0	55	14		219	219	99
0	66	5	7		237	81	0
30	5	15	10		159	192	180
55	37	0	27		85	94	137
14	22	15	18		179	154	93
66	70	28	55		41	26	51

C	M	Y	K		R	G	B
0	13	7	0		253	222	222
7	77	44	0		232	59	88
0	6	55	27		186	175	81
0	44	88	22		198	112	19
0	27	88	0		255	186	28

C	M	Y	K		R	G	B
30	26	0	10		158	151	188
11	0	22	4		218	234	188
0	44	22	0		250	144	155
88	5	21	0		33	157	166
88	70	22	0		40	51	119
30	30	70	20		143	125	56

C	M	Y	K		R	G	B
30	26	0	10		158	151	188
11	0	22	4		218	234	188
0	44	22	0		250	144	155
88	5	21	0		33	157	166
88	70	22	0		40	51	119
30	30	70	20		143	125	56

TOY BOX It's made of pressed tin that has been printed in eight colors. When wound up with the brass key (included), it darts about the floor making tight circles and turning somersaults at intervals. It's a Chinese toy dragon that you get for free when you purchase the cool cardboard box shown above. Who could ask for anything more?

C	M	Y	K		R	G	B
30	30	70	20		143	125	56
4	0	62	0		245	251	98
63	0	27	0		95	190	169
0	36	95	0		255	163	14

C	M	Y	K		R	G	B
7	93	100	0		237	20	0
40	0	0	100		0	0	0

FUROSHIKI In Japan, the question, "Paper or plastic?" fails to take into account the furoshiki option. Used for wrapping just about everything, the furoshiki is an elegant, multicolored square of decorative cloth that is the last word in recycling. Over in Europe, many shops still wrap in plain sheets of paper, rather than in wasteful paper or plastic bags, but the Japanese have taken the art of wrapping to another level.

12 90 100 **0**		224 25 0
7 30 27 **0**		234 175 157
35 16 43 **0**		166 183 131
15 34 95 **5**		206 149 25

38 31 37 **5**		150 142 125
66 33 16 **16**		75 107 135
47 34 63 **43**		77 76 47
3 13 17 **0**		246 220 197

0 60 55 **0**		251 103 80
0 90 65 **10**		226 24 44
40 25 30 **0**		153 161 149
40 0 0 **100**		0 0 0

10 35 0 **3**		219 156 200
30 60 40 **25**		133 68 79
10 30 60 **25**		171 129 65
10 100 100 **30**		161 0 0
White		255 255 255

14 20 77 **0**		218 191 57
0 75 80 **10**		228 59 29
5 3 10 **5**		229 230 213
10 20 30 **0**		228 196 159

10 80 25 **0**		223 51 114
0 3 5 **3**		247 239 231
60 0 55 **0**		102 190 118
100 0 70 **40**		0 86 59
40 0 0 **100**		0 0 0
White		255 255 255

CMYK		RGB
10 65 65 **10**		205 78 55
5 3 10 **0**		242 242 224
35 0 50 **30**		116 153 89
20 0 65 **30**		143 163 65
40 45 50 **15**		130 100 83
40 0 0 **100**		0 0 0

CMYK		RGB
0 50 70 **0**		253 128 57
0 25 80 **0**		254 191 45
30 35 40 **0**		178 146 124
65 65 0 **0**		94 69 157
40 0 0 **100**		0 0 0
White		255 255 255

CMYK		RGB
3 0 3 **15**		210 214 209
70 35 0 **5**		99 123 178
50 5 5 **10**		92 169 186
60 0 40 **15**		87 163 124

CMYK		RGB
0 85 85 **10**		228 36 20
0 70 100 **0**		255 76 0
0 20 100 **0**		255 204 0
60 0 80 **10**		92 168 64
85 50 0 **10**		41 79 149

INCENSE PACKAGE In Taoist and Buddhist belief, joss sticks (a form of incense) are used to get in touch with one's relatives in the netherworld. Or, you could call the psychic hotline and skip the aroma. The surprising combination of Mt. Fuji's brilliant yellow and the pink sky are the Oriental-color tip-off here. Just by keeping the box around, it's amazing how your house can reek of chrysanthemum for days.

CMYK		RGB	CMYK		RGB
24 35 95 **5**		184 140 19	S 87 18 **0**		14 21 111
0 19 100 **0**		255 207 0	0 30 3 **0**		251 180 210
30 34 0 **0**		178 150 200	White		255 255 255
53 30 0 **0**		121 144 195			

寿

70 40 0 **11**		79 112 162
0 33 70 **11**		226 153 57
0 90 100 **33**		171 17 0
15 3 15 **0**		217 233 208

77 11 55 **0**		60 153 112
30 13 44 **0**		179 195 132
0 90 55 **33**		167 18 42
7 11 22 **0**		236 221 186
40 0 0 **100**		0 0 0

GREETING CARD Masako Sakai, Michie Sahara, artists. Sakai is a former child actor of the silent era of Japanese films who has rediscovered the 200-year-old Rokoan method of highly complex origami. Sahara was a teenage pop music sensation in Japan. In their spare time, they've created greeting cards of simplified origami utilizing exotic, hand-printed papers. Sakai and Sahara are also mother and daughter.

0 60 80 **0**		253 103 36
25 47 90 **20**		153 96 21
50 40 5 **0**		128 125 177
42 25 82 **23**		114 119 39

19 22 50 **0**		206 184 113
0 87 100 **0**		255 34 0
3 3 9 **0**		247 244 227

100 75 15 **30**		9 28 87
60 35 15 **25**		78 96 122
20 3 3 **5**		194 217 221
100 0 40 **40**		0 90 85
10 35 85 **10**		207 143 31

20 63 100 **15**		174 73 2
60 11 44 **25**		77 128 98
20 3 3 **5**		194 217 221
100 0 40 **40**		0 90 85
17 4 60 **0**		212 227 102
White		255 255 255

30	50	0	**0**			177	114	182	
20	20	0	**0**			203	189	220	
55	35	35	**0**			116	130	130	
85	50	0	**45**			25	47	89	
15	25	55	**0**			213	181	99	

30	50	0	**0**			177	114	182	
20	20	0	**0**			203	189	220	
33	20	20	**0**			171	178	174	
55	35	35	**0**			116	130	130	
85	50	0	**45**			25	47	89	
15	25	55	**0**			213	181	99	
			White			255	255	255	

80	44	0	**0**			56	101	172	
0	100	100	**10**			230	0	0	
20	30	70	**15**			173	139	58	
100	70	20	**30**			7	33	84	
15	10	30	**0**			216	216	167	

95	100	0	**0**			31	0	124	
0	95	100	**0**			255	17	0	
8	21	46	**0**			234	195	123	
20	30	70	**15**			173	139	58	
100	11	100	**0**			0	121	49	
75	20	0	**0**			67	147	195	
			White			255	255	255	

TORN PAPER ART Michie Sahara, artist. Inspired by an exhibition of traditional Japanese art made entirely from torn rice papers, Sahara returned home to create this simple masterpiece. The torn paper edges create a most pleasing effect resembling watercolor bleeding into the wet. Sadly, Sahara unexpectedly passed away while this book was still in production.

30	38	10	**0**			178	141	177	
30	62	44	**22**			138	67	76	
20	44	63	**0**			203	131	75	
47	33	75	**30**			95	95	43	

27	11	60	**0**			186	201	99	
13	22	7	**0**			220	190	206	
8	21	46	**0**			234	195	123	
3	3	9	**0**			247	244	227	

DECORATIVE PAPER A rayon housedress from the 1960s? No, just one of a seemingly endless selection of gorgeous decorative papers from Japan. This design, however, is somewhat less gorgeous, but still intriguing. It feels to me like a lovely spring day as seen through a haze of heavy Tokyo smog.

13	42	0	3		211 138 191
0	77	30	0		247 62 110
27	77	3	20		145 45 118
55	44	0	0		117 115 180

22	27	55	20		159 135 80
4	0	0	0		245 251 253

25	44	28	0		189 125 138
0	12	25	0		254 223 179
100	75	0	0		15 41 143
25	6	6	0		191 217 221
0	70	42	0		249 76 95
42	18	62	0		149 172 94

20	20	80	0		204 186 51
10	15	28	15		195 178 143
77	22	90	22		46 100 38
0	29	39	0		252 182 133
0	54	71	11		225 107 47
40	0	0	100		0 0 0

15	75	0	30		147 45 110
10	50	70	10		206 110 52
0	10	20	0		254 230 194
60	0	100	40		61 110 150
40	0	0	100		0 0 0

0	50	100	0		255 127 0
0	25	80	0		254 191 45
80	60	0	20		46 58 127
0	50	15	0		249 129 162
0	85	85	20		203 32 18
			White		255 255 255

CMYK					RGB		
88	44	0	**0**		38	97	169
0	100	66	**0**		250	0	43
35	0	60	**30**		116	152	74
22	0	0	**0**		199	234	242
0	25	0	**0**		251	192	223

CMYK					RGB		
8	44	10	**0**		230	140	177
25	50	55	**0**		189	114	86
70	90	100	**0**		75	17	2
100	10	0	**0**		1	144	191
95	11	88	**0**		17	130	76
White					255	255	255

CMYK					RGB		
0	15	35	**5**		241	206	146
20	66	70	**15**		172	68	44
77	11	0	**0**		63	163	202
0	50	85	**0**		254	127	31
0	100	90	**0**		254	0	13
40	0	0	**100**		0	0	0

CMYK					RGB		
11	0	50	**0**		227	243	127
0	100	90	**0**		254	0	11
72	54	0	**0**		77	87	166
40	0	0	**100**		0	0	0
White					255	255	255

DECORATIVE PAPER The traditional colors and patterns in this paper are commonly used in Kabuki theatre. There is an interesting randomness in the placement of colors—note the way white appears here and there in the design though not symmetrically. Sloppy color separating? Not by the Japanese! There must be some mystical meaning lost on the occidental observer far outside the Kabuki loop.

CMYK					RGB		
65	56	0	**0**		86	80	154
0	20	62	**7**		236	190	81
45	18	3	**0**		140	174	205
40	0	0	**100**		0	0	0
White					255	255	255

TRIPTYCH PAINTING Hyunsook Cho, artist. The three house-shaped forms refer to the artist's physical relocation from her native Korea, through an uncertain period of acclimation, to her present domicile in the U.S. The colors—only incidentally those of both the U.S. and Korean flags—are richly patinated in reference to the way some brightly painted Korean furniture ages with time.

CMYK	RGB		CMYK	RGB
83 55 25 24	38 59 96		18 93 85 6	195 18 20
53 34 6 3	118 131 175		16 52 44 4	203 110 101
12 15 16 0	223 207 194		White	255 255 255
21 22 11 0	200 183 194			

CMYK	RGB
0 90 100 18	209 21 0
100 100 0 15	16 0 104
0 33 0 0	250 169 211
70 37 0 0	79 117 181
10 53 70 0	228 115 55

CMYK	RGB
0 100 80 0	252 0 25
90 65 0 20	28 48 122
40 0 0 100	0 0 0
White	255 255 255

CMYK	RGB
0 70 0 10	221 71 149
0 75 75 0	252 65 40
80 0 70 10	46 149 84
40 0 0 100	0 0 0
White	255 255 255

CMYK	RGB
0 60 100 0	255 102 0
100 0 100 20	0 109 44
50 70 0 10	116 57 140
90 65 0 20	28 48 122
15 5 0 0	217 229 240
0 3 5 20	204 198 191
40 0 0 100	0 0 0

CMYK		RGB
30 0 70 **20**		143 177 67
80 0 100 **40**		31 96 26
0 15 100 **10**		230 196 0
0 85 85 **10**		228 36 20
40 0 0 **100**		0 0 0
White		255 255 255

CMYK		RGB
0 30 20 **3**		230 174 171
60 25 0 **0**		92 148 173
0 60 40 **30**		175 73 75
40 0 50 **15**		130 180 108
10 5 3 **0**		230 233 236
0 40 70 **10**		228 138 56
40 0 0 **100**		0 0 0

CMYK		RGB
0 50 0 **0**		247 129 191
15 0 75 **10**		196 215 62
100 0 35 **20**		1 121 118
100 5 5 **0**		1 151 187
0 15 50 **5**		241 206 111
30 70 100 **30**		126 47 2

CMYK		RGB
0 100 70 **0**		250 0 38
0 25 95 **0**		255 191 15
10 100 10 **0**		219 1 114
80 70 0 **0**		60 55 150
70 0 80 **0**		77 175 74
40 0 0 **100**		0 0 0

PAINTING ON WOOD Hyunsook Cho, artist. This painting, *Immortal Peach*, is dedicated to three of Cho's friends who suffered through breast cancer. A further reference is made to an old Chinese and Korean fable of goddesses who elude death by their yearly ingestion of the immortal peach. Despite the peach's tonal complexity, the colors we've harvested below have yielded rather delicious layouts.

CMYK		RGB
15 74 100 **0**		217 62 1
13 46 64 **0**		220 131 72
53 43 38 **22**		95 89 93
100 29 11 **66**		0 32 47

CMYK		RGB
25 72 95 **11**		170 56 12
31 47 56 **20**		140 94 69
40 0 0 **100**		0 0 0

BOOK COVER This cover for *The Barefoot Monk* by Han Sungwon would seem to be a good example of Korean computer graphics. Mitigating the Korean taste for hard edges and bright colors, a softer, flowing background has been added to indicate the windswept sand dunes undoubtedly traversed by the unshod Zen master in the book.

70 52 42 **77**		80 87 105	
67 17 100 **6**		79 137 29	
0 79 93 **0**		254 55 13	
65 59 20 **33**		62 53 90	

24 24 7 **0**		193 177 199	
45 45 14 **10**		127 105 143	
White		255 255 255	

0 30 3 **0**	251 180 210
0 5 20 **0**	255 242 199
40 0 25 **5**	146 204 170
50 30 0 **0**	128 146 196
0 0 55 **15**	217 217 98
40 0 0 **100**	0 0 0
White	255 255 255

0 30 40 **5**	239 170 123
0 90 65 **0**	250 27 49
85 50 0 **0**	46 87 165
25 15 0 **0**	190 197 224
0 70 100 **40**	153 46 0
30 30 50 **5**	169 149 102
White	255 255 255

0 0 55 **0**	255 255 115
0 30 15 **0**	251 180 185
95 25 0 **0**	21 124 182
55 0 50 **5**	110 186 120
40 75 80 **25**	114 40 26
White	255 255 255

45 0 50 **15**	119 176 108
90 0 65 **20**	21 125 83
10 0 5 **3**	223 238 229
0 10 10 **0**	254 230 219
0 65 70 **20**	202 72 41
100 60 0 **0**	12 65 154

5	52	0	**0**		235 122 187
0	100	71	**0**		251 0 37
100	0	39	**6**		0 142 134
0	54	82	**0**		254 118 34
40	0	0	**100**		0 0 0
		White			255 255 255

0	10	100	**0**		251 230 0
0	93	0	**0**		241 24 134
29	0	100	**0**		181 220 16
93	45	0	**0**		28 92 167
0	28	10	**0**		251 185 198
40	0	0	**100**		0 0 0

KOREAN MONEY

KOREAN MONEY To look at this gorgeous 1000 won note (about 75¢) is to become even more frustrated with American banknotes, especially the recent, simplified versions that seem to have been designed from Dover clip art. Function forgoes form with American money. It's that magnetic stripe that'll allow them to scan your house or your person to tell how much you're carrying that was the chief concern of the new bills' designers. The man on the money above is the famous Korean Confucian scholar Yi Hwang (T'oegye, 1501–1570).

0	30	60	**0**		253 179 87
40	60	0	**0**		152 89 168
30	0	S	**20**		143 176 13
90	75	75	**0**		29 39 45

100	5	20	**30**		1 103 116
30	3	0	**3**		174 213 227
0	15	0	**3**		245 211 228
5	5	5	**15**		205 202 198
40	0	0	**100**		0 0 0
		White			255 255 255

33	75	44	**22**		132 44 69		87	40	51	**26**	27 72 74
6	26	20	**0**		237 185 176		16	70	24	**4**	201 71 119
52	10	44	**0**		123 180 132		15	43	88	**3**	210 131 27
76	43	0	**0**		67 105 174		0	7	3	**0**	254 237 173

3 9 35 **0**		249 230 158
31 9 35 **10**		159 183 138
0 95 100 **0**		255 17 0
11 9 40 **49**		115 113 74
40 0 0 **100**		0 0 0

10 20 100 **0**		230 195 3
50 20 100 **14**		109 134 19
33 84 68 **11**		151 33 43
61 17 47 **74**		26 41 31
8 8 12 **6**		220 215 199

BOOK COVER The title of this undoubted literary masterpiece is *Blood on the Road*. It is but one of the hundreds of action/adventure titles one encounters for sale in roadside kiosks and cluttered bookstalls in Vietnam. There is an innocent quality to such works, but it struck me that this tiny nation, under somebody's domination or interference for so much of its existence, may need outlets like these stories.

0 68 69 **0**		252 83 52
0 4 70 **0**		255 245 76
3 20 40 **0**		245 202 137
24 50 46 **12**		166 101 99

39 18 30 **10**		141 159 140
40 0 0 **100**		0 0 0

33 84 68 **11**		151 33 43
8 88 0 **0**		224 34 142
5 29 0 **0**		238 179 216
25 22 0 **0**		190 181 216
51 9 59 **27**		91 132 76
61 17 47 **74**		26 41 31

6 57 68 **0**		238 108 59
32 57 49 **0**		172 96 92
0 25 17 **0**		252 192 185
24 89 72 **11**		169 23 35

50 45 0 **9**		117 105 165	
45 59 94 **9**		127 76 19	
0 3 63 **0**		255 247 93	
45 59 64 **59**		58 35 28	
29 5 0 **10**		163 195 210	

21 5 0 **0**		201 223 237	
44 5 31 **0**		144 199 162	
21 23 0 **23**		153 139 166	
0 3 63 **0**		255 247 93	
79 17 9 **55**		26 67 82	

0 50 50 **0**		251 128 95	
28 81 79 **0**		183 43 34	
8 7 7 **39**		143 141 138	
26 0 39 **0**		189 228 153	
40 0 0 **100**		0 0 0	

8 14 100 **3**		228 204 2	
12 28 100 **11**		199 154 3	
54 23 71 **11**		105 133 67	
27 4 6 **0**		186 220 222	
3 4 13 **3**		239 234 209	
37 52 76 **39**		98 63 31	

PAINTING This contemporary work by an unknown artist depicts a patriotic scene from Vietnam's past, perhaps during the 1000 years of occupation by China since the flags bear Chinese inscriptions. With its bright color and naïve style, it is certainly a work of folk art, even to the reed-woven frame that the original art came bound up in. The mystery of the green horse remains unanswered.

75 0 95 **4**		62 160 48	
0 0 90 **0**		255 255 26	
0 94 0 **0**		241 22 135	
90 60 6 **22**		27 53 116	

0 100 87 **3**		245 0 16	
0 32 4 **0**		251 174 205	
40 0 0 **100**		0 0 0	
White		255 255 255	

0 90 100 **29**		181 19 0	
35 49 0 **0**		165 115 182	
0 25 100 **0**		255 191 0	
40 0 0 **100**		0 0 0	
White		255 255 255	

6 11 6 **0**		238 222 233	
17 49 60 **0**		210 121 78	
40 26 40 **0**		153 158 129	
40 0 0 **100**		0 0 0	

TIBETAN TAPESTRY Even from Nepal, where many Tibetan refugees from brutal Chinese expansionism reside, the crafts and culture of the "land above the clouds" live on. The hand-painted central image above portrays Kala Chakra, the deity of compassion. Although it was recently painted—so delicately that there is nary a brushstroke to be seen—the work looks as if it were centuries old.

62 33 33 **41**		58 76 79	
13 53 51 **6**		206 108 86	
44 20 13 **7**		133 158 171	
0 8 44 **0**		255 235 137	

33 12 27 **0**		171 197 168	
18 69 66 **32**		140 50 39	
10 20 49 **3**		222 190 113	
4 0 0 **0**		245 251 253	

26 67 13 **7**		172 72 133	
19 94 77 **22**		160 14 25	
25 48 77 **7**		177 110 45	
71 57 13 **58**		33 34 61	
4 10 0 **0**		244 227 240	
0 33 6 **7**		233 160 186	

100 61 0 **0**		12 63 153	
40 23 16 **0**		154 166 177	
90 90 0 **49**		20 9 68	
8 15 0 **0**		233 211 232	

0 72 82 0	253 72 30
94 15 7 35	14 91 117
7 10 14 0	236 224 206
75 25 93 0	65 125 42
21 24 67 0	201 176 77

7 80 100 0	237 49 0
6 22 100 14	206 166 0
0 6 55 4	245 230 107
40 0 0 100	0 0 0

TIBETAN BANNER Centered on this embroidered banner is the Tibetan symbol of world peace. Each of the colors has a meaning: red—fire; yellow—light; green—earth; white—air; blue—water. Pretty intuitive; no surprises here! What *is* a surprise is that the beautiful Tibetans, despite their own dire circumstances, continue to lobby for the greater good of mankind.

100 60 0 44	6 36 86
0 55 100 5	242 109 0
0 75 75 10	228 59 36
90 0 70 10	24 139 87
0 14 90 0	255 219 24

43 25 77 26	108 114 45
88 25 59 39	217 73 60
43 100 46 26	107 0 50
31 26 0 8	162 155 192
90 64 10 22	28 48 109
6 22 66 4	230 186 75

0 31 100 0	255 176 0
0 90 100 0	255 26 0
100 64 17 7	10 53 119
87 9 100 17	28 114 36

65 7 18 0	90 177 179
7 42 18 0	233 145 163
40 0 0 100	0 0 0
3 45 0	247 242 236

SOAPBOX Krishna and and his lover Radha are the most important deities of Bengali Vaishnavism. I would be surprised to see Jesus on a bar of Ivory soap, but religion and religious imagery are ubiquitous in many countries like India. It's kind of nice, though, that former milkmaid Radha gets to share center stage with Krishna and provide a positive role model for female worshippers.

CMYK		RGB
5 58 94 0		242 105 14
14 83 94 0		218 41 12
60 25 84 20		82 111 42
53 50 55 30		85 70 61

| 40 0 0 100 | | 0 0 0 |

CMYK		RGB
30 30 70 10		161 141 63
5 38 17 0		238 156 170
15 92 65 0		214 22 48
22 0 0 16		167 196 203

CMYK		RGB
30 37 100 10		162 125 9
30 100 70 30		125 0 27
66 0 77 0		87 180 78

CMYK		RGB
5 38 17 0		238 156 170
16 75 45 17		175 51 72
0 9 100 0		255 232 0
59 9 100 0		105 168 30
40 0 0 100		0 0 0

CMYK		RGB
62 0 86 0		97 183 61
42 13 18 33		99 125 122
14 0 62 0		219 239 99

11 0 15 **16**		191 205 178
9 0 85 **0**		232 245 43
9 66 0 **0**		224 87 169
70 80 0 **0**		84 39 143
90 0 10 **22**		21 131 147

0 8 15 **11**		226 209 85
30 70 100 **15**		152 56 3
10 40 100 **0**		227 145 2
66 66 44 **66**		0 0 0

5 100 79 **0**		239 0 27
21 6 9 **17**		166 182 178
70 6 100 **0**		77 162 36
White		255 255 255

5 100 79 **0**		239 0 27
5 38 17 **0**		238 156 170
32 10 14 **25**		130 151 147

GREETING CARD This is not a costume fragment from one of Elvis' last appearances in Vegas. It's an ornate greeting card from India. In contrast to the fine and delicate decorative work in gold is the careless manner in which the card is cut and folded. For some reason, quality printing has never been high on India's list of achievements. However, the funky results are charming and the colors are oddly wonderful.

65 10 88 **24**		68 123 41
0 45 13 **0**		249 142 172
15 15 70 **3**		210 196 72
14 49 93 **9**		199 111 17

KRISHNA PRINT Dating from the 1930s, this eight-color print, including silver leaf, depicts the god Krishna (one of the most important incarnations of the deity Vishnu) with Radha the milkmaid. Such a print would have formed the center-piece of many an Indian home altar. Rich in esoteric symbolism, the colors of this print are also richly harmonious and not too garish (see opposite), presumably due to its age.

CMYK	RGB		CMYK	RGB
21 32 80 18	164 128 39		64 15 42 30	66 112 92
14 30 100 3	212 162 4		15 33 44 10	194 145 107
13 76 100 9	202 53 0		40 0 0 100	0 0 0
27 19 26 0	186 185 165		White	255 255 255

CMYK	RGB
0 47 77 7	236 126 42
0 22 51 0	254 199 111
64 0 0 0	93 194 219
30 80 100 18	147 34 1

CMYK	RGB
4 30 0 0	241 178 215
31 46 0 0	174 123 186
35 7 79 30	117 140 44
79 87 0 0	65 25 136
0 83 100 0	255 44 0
27 19 26 0	186 185 165
White	255 255 255

CMYK	RGB
11 71 90 15	193 60 15
11 43 50 4	215 133 95
100 66 0 0	13 55 149
0 31 0 0	250 177 215
40 0 0 100	0 0 0
White	255 255 255

CMYK	RGB
57 86 0 0	114 31 139
7 31 0 0	233 173 213
46 0 100 0	138 200 25
27 19 15 0	185 186 187
73 33 12 22	59 97 130
40 0 0 100	0 0 0
White	255 255 255

9 33 85 **18**	190 136 29
7 11 28 **6**	220 206 161
32 15 89 **30**	122 130 27
0 100 100 **0**	255 0 0
40 0 0 **100**	0 0 0

50 0 70 **0**	125 198 86
12 0 38 **0**	224 241 156
78 0 12 **0**	57 179 190
78 18 12 **30**	41 103 123
7 11 28 **6**	220 206 161
5 40 67 **16**	202 128 58

42 51 0 **0**	148 107 177
0 45 32 **0**	251 141 134
28 100 0 **0**	178 1 126
40 0 0 **100**	0 0 0
White	255 255 255

16 88 0 **0**	206 33 141
15 0 0 **25**	162 180 184
32 0 0 **52**	81 105 111
40 0 0 **100**	0 0 0
White	255 255 255

KALI PRINT She laughs loudly, she dances madly. She is a goddess who threatens stability and order. She is the blood-thirsty Kali who, while slaying demons (good), tends to get drunk on blood and starts destroying the world (bad), which is no less dysfunctional behavior than our own Western deity who's always smoting people right and left. This image of Kali, in all her cyan beauty, is a contemporary one.

84 0 0 **0**	43 175 207	50 13 100 **30**	86 101 19
0 39 19 **0**	250 157 167	0 100 100 **0**	255 0 0
0 32 100 **0**	255 173 0	40 0 0 **100**	0 0 0
0 9 20 **0**	254 232 195	White	255 255 255

19 80 54 **22**		159 36 54
7 33 7 **7**		217 156 182
37 6 50 **10**		145 183 111
64 15 42 **30**		66 112 92
40 0 0 **100**		0 0 0
White		255 255 255

10 10 35 **20**		184 177 125
0 30 100 **35**		166 116 0
15 70 90 **30**		152 51 13
3 9 38 **0**		246 229 150
40 0 0 **100**		0 0 0

MAJOLICA TILE The tiles on these pages, dating from the 1930s, came off a wall in Gujarat. Well, they were loose. Sort of. There is a wonderful "airbrushed" quality to this style of tile, called *majolica*. Such tiles use almost transparent glass glazes that float sensuously through channels on the molded surfaces of the tiles and intermingle at the junctures where the colors meet. Can you tell I'm a tile freak?

46 30 33 **0**		138 146 139	78 39 45 **45**		32 58 60
3 15 45 **0**		246 214 129	62 28 80 **40**		59 80 35
35 39 36 **0**		165 135 127	68 29 40 **13**		73 114 108
29 83 93 **37**		114 24 9			

33 89 72 **0**		170 25 40
0 53 37 **10**		224 109 106
42 19 26 **0**		148 173 161
3 10 21 **0**		246 227 190
33 89 72 **41**		100 15 23

0 85 85 **35**		165 26 15
0 45 60 **0**		252 141 79
4 13 9 **6**		229 206 203
40 57 49 **42**		89 54 53
27 38 33 **29**		133 101 96

0 85 85 **35**		165 26 15
0 30 90 **0**		255 179 22
20 15 30 **5**		193 190 153
40 33 49 **42**		89 83 62
4 7 9 **6**		230 220 209

36 20 9 **0**		163 177 195
40 100 33 **47**		80 0 45
40 30 60 **25**		115 111 67
0 30 100 **16**		214 150 0

MAJOLICA TILE Another tile that came (actually) from a little antique stall in Gujarat, a city in northwest India. The light green and light blue colors, so startling against the darker, grayed-down colors, seem so typically Indian. Yet upon closer inspection, we find the backs of these tiles marked "Japan," indicating that they were actually imported into India from Japan. Another color theory shot to hell.

31 0 33 **0**		176 223 165
0 26 76 **0**		254 189 54
51 0 16 **0**		126 205 194
26 95 91 **15**		160 13 11

65 26 37 **13**		79 121 115
50 36 67 **24**		97 97 57
40 0 0 **100**		0 0 0
11 4 16 **0**		227 235 206

30 75 100 **15**		152 47 2
100 5 20 **15**		1 125 141
5 7 67 **0**		242 232 82
5 30 100 **10**		218 158 1

0 20 10 **10**		230 184 0
100 0 80 **40**		0 85 50
33 90 100 **22**		133 17 1
28 36 76 **0**		184 143 55

SHIRT FRONT Embroidery such as this is created on a backing sheet and then sewn onto clothing. I call the green fabric of this embroidered shirt "Pakistan green." It is so often used, it seems to be the national color. Shami, the designer from across the gutter to this page, says, "I don't think that there is an 'official' mix for this green, but it's something like 100C/0M/ 85Y/15K." Well, our green below is pretty close.

C	M	Y	K		R	G	B
67	22	62	37		26	86	62
16	100	68	23		162	0	31
8	93	100	0		235	20	0
100	70	8	15		11	41	116

C	M	Y	K		R	G	B
4	19	100	0		245	203	1
7	10	16	0		236	224	201
40	0	0	100		0	0	0

C	M	Y	K		R	G	B
20	0	75	0		204	232	70
15	23	100	0		217	182	6
7	6	47	0		237	233	131
27	18	14	13		161	163	165
35	46	100	12		145	100	9
40	0	0	100		0	0	0

C	M	Y	K		R	G	B
20	6	35	3		198	214	153
11	33	70	33		151	109	44
45	90	69	18		115	18	36
40	47	0	8		141	107	168

C	M	Y	K		R	G	B
32	0	85	0		173	218	51
0	90	100	0		255	26	0
82	21	100	0		47	124	36
40	0	0	100		0	0	0
White					255	255	255

C	M	Y	K		R	G	B
0	90	0	0		241	25	137
17	27	0	0		210	175	213
15	50	0	51		104	60	91
40	0	0	100		0	0	0
White					255	255	255

16 100 68 **35**		137 0 36
3 71 68 **9**		222 67 48
0 41 49 0		252 151 103
69 47 8 0		77 93 159
40 0 0 **100**		0 0 0

35 35 56 **18**		136 116 77
7 44 75 **0**		236 139 51
0 26 62 0		254 189 85
32 39 62 **65**		60 47 28
White		255 255 255

29 26 31 **0**		180 167 148
14 17 40 **0**		218 200 139
21 41 62 **0**		193 135 79
66 69 70 **22**		69 44 42
56 61 64 **0**		113 76 67
7 11 18 **0**		236 221 195

74 14 50 **0**		68 151 117
4 4 23 **0**		245 241 191
45 78 73 **0**		140 46 44
88 75 0 **0**		43 44 145

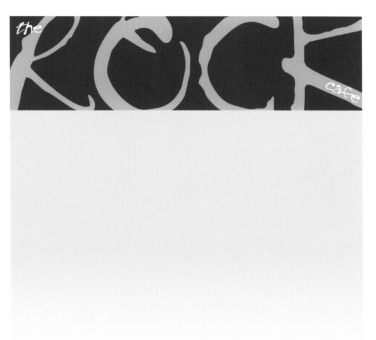

CAFE LETTERHEAD Ahsan R. Shami, designer. This masthead was designed for a restaurant in Karachi that is a takeoff on the Hard Rock Cafe concept. The colors spoke "retro" to the cafe owner, a big fan of Led Zeppelin, the Rolling Stones, the Beatles and Jethro Tull. Shami, an AD at GDcooya Design, Karachi's hottest young agency, explains, "The grungy type achieved a hip, young feel that was appropriate for the age group the proprietor was targeting."

89 94 20 **8**		37 12 96
0 49 100 **0**		255 130 0
0 10 44 **0**		254 230 136
White		255 255 255

AMERICAN

I'm sitting on the beach at Cannes in the south of France and overhear one American tourist say to another, "When I get back to Chicago, first thing I'm gonna do is find a Taco Bell." Well, I must admit, it's nice to be back in the U.S.A. where I speak the language fluently and can successfully order a meal. ■ Having traversed this wide world of ours, I am proud to say that in America we have the best colorists on earth (working for us…at well below minimum wage). ■ But who are the true American designers? Illustrator Mark Frauenfelder's ancestors came from Switzerland and Russia. Also featured in this chapter are Lyle Carbajal (Spain–Italy), Overton Lloyd (Africa-Creole Indian), Jean Tuttle (England), Mark Fisher (Germany), David Brooks (German-Irish) and Leslie Cabarga (Spain/Cuba-Romania/Russia-England). The only true Americans are the indigenous population whose colors are represented in this chapter because of that fact. Yet some say even the Native Americans arrived from Asia across the Bering Strait, or as refugees from the sinking continent of Atlantis. ■ All that said, there's *something* about America that is special. That's why every Polish au pair girl who steps foot on our soil never wants to leave. ■ Compared to Europe and many other countries, we are an adolescent nation that Gore Vidal has aptly dubbed, "The United States of Amnesia." The latest celebrity gossip causes us to forget about which third world country America is currently using for target practice. We vote for the presidential candidate with the most advertising (provided he's a man). And we reject sex education so our children won't do what we effectively urge them to do in every TV sitcom, rock video and advertisement. ■ Despite its flaws, I ♥ AMERICA. But I want us to embody the freedoms guaranteed by the Bill of Rights, not just give lip service to them. ■ Oh yeah, I'm supposed to talk about color. American colors are as diverse as our people. Like mutts, said to be more clever than purebred dogs, we are the beneficiaries of all the cultural crossbreeding that goes on here and I think that's nice.

COLOR

"BEAR PAW DOWN" MEDICINE BAG Allen LeGarreta "Crying Bear," designer. Every part of this medicine bag crafted by young Yaqui tribesman Crying Bear has meaning. The "bear paw down" symbol stands for "hold your heart." Turquoise beads mean "having value." And the "sun child face" in the center of the paw is the personal symbol of the artist, meaning "don't worry about the past."

65 15 30 **7**		84 149 142	
15 89 100 **13**		189 23 0	
7 10 14 **0**		236 224 206	
14 38 55 **9**		198 136 85	

40 0 0 **100** 0 0 0

Cochiti

3 8 45 **0**		247 232 134	
39 54 51 **25**		117 74 68	
27 82 100 **13**		162 36 1	
84 0 0 **14**		37 150 178	
0 12 15 **17**		211 186 169	

Navaho

76 7 27 **0**		63 165 160	
39 40 42 **36**		100 83 74	
0 9 66 **14**		219 199 72	
0 43 27 **19**		203 119 118	
17 13 30 **0**		210 207 163	

Ute

27 46 20 **12**		162 109 133	
14 25 11 **6**		201 169 180	
90 36 100 **0**		29 95 31	
15 100 65 **13**		186 9 39	
10 28 80 **0**		229 176 49	
White		255 255 255	

Haida

45 30 0 **0**		140 150 198	
0 14 70 **9**		232 199 65	
8 70 100 **8**		216 68 0	
40 0 0 **100**		0 0 0	
White		255 255 255	

Zuni

5 5 0 **5**		229 225 233	
8 38 35 **4**		223 148 128	
45 49 53 **22**		109 83 71	
87 49 53 **40**		23 50 55	

Navaho

0 79 100 **8**		232 49 0	
100 18 100 **18**		0 91 37	
100 39 15 **45**		2 50 78	
24 75 75 **27**		141 43 30	

Hopi

0 70 100 **8**		235 71 0	
65 10 100 **9**		81 146 30	
18 51 90 **27**		152 70 15	
40 0 0 **100**		0 0 0	
White		255 255 255	

Apache

5 25 100 **7**		225 173 1	
20 100 78 **8**		184 0 25	
83 100 17 **27**		40 0 75	
40 0 0 **100**		0 0 0	
White		255 255 255	

RAVEN MEDICINE BAG Allen LeGarreta "Crying Bear," designer. The colors of the antique, 19th century beads recycled by the artist in the bag above are significant: white—great life; red—great heart; blue—strong feelings; black—earth guidance; yellow—sun/being happy. Apache elder Standing Bear passed on to Crying Bear such Native American traditions as storytelling and beadwork (and Allen also does tattoos).

7 9 9 **0**		236 226 218	
100 16 16 **13**		2 114 142	
13 32 68 **7**		205 152 66	
12 90 85 **9**		202 23 20	

25 45 60 **20**		152 100 64	
40 0 0 **100**		0 0 0	

PHOTOGRAPH The black channel from the CMYK scan of this 1902 portrait of a Pueblo woman revealed no undercolor removal, indicating that it was probably hand tinted. "UCR" avoids over-saturation of ink in dense areas although it can leave annoying "bald spots" when other colors are reduced by image editing. The colors above are undoubtedly not true-to-life, although the photo presents a fascinating window into the past.

4 79 87 0		244 54 21	7 12 19 0		236 218 192
21 73 79 40		83 116 121	15 19 25 5		205 185 161
8 29 62 0		234 175 84	20 45 87 45		112 70 17
10 61 95 3		222 92 13	59 24 25 22		120 38 22

Blackfeet

56 26 0 **13**		99 131 172		
100 39 31 **20**		3 75 102		
12 29 82 **0**		223 171 43		
0 89 100 **12**		224 25 0		
White		255 255 255		

Bannack-Shoshonean

0 75 100 **21**	201 51 0
45 34 100 **13**	122 115 14
7 37 100 **13**	206 135 1
41 70 81 **41**	88 37 21
4 9 12 **7**	227 213 197

Dakota Sioux

20 83 100 **0**	204 40 1
67 16 100 **29**	60 104 22
18 12 28 **0**	208 208 169
27 48 74 **35**	121 76 35

Crow

15 71 43 **0**	213 71 93
100 50 0 **0**	10 80 161
46 18 100 **0**	138 164 21
11 12 17 **0**	226 215 195

Apache

16 45 83 **0**		213 130 37	
37 72 92 **0**		161 59 18	
80 42 0 **0**		57 105 174	
15 82 73 **0**		215 44 41	
40 0 0 **100**		0 0 0	
White		255 255 255	

Navaho

8 42 27 **0**		231 145 146	
15 71 48 **0**		213 71 85	
59 85 59 **18**		88 25 49	
White		255 255 255	

Minitari Hidatsa

16 17 21 **13**		185 172 156	
15 71 73 **0**		215 70 46	
5 7 63 **0**		242 232 92	
59 85 80 **0**		106 29 32	
6 6 9 **0**		239 234 222	

Cheyenne

55 35 0 **0**		117 133 189	
15 71 43 **0**		213 71 93	
100 60 0 **16**		10 54 129	
4 7 62 **0**		245 233 94	
White		255 255 255	

AWATOVI WALL ART This image is actually an archaeological re-creation of a mural from an excavated pueblo wall dwelling at Awatovi in Arizona. Like the opposite image, it's a bogus, paleface version of Native American art, though I believe it is an exceedingly careful and respectful rendition. In America, we persecute people like the Native Americans, Dr. Martin Luther King and César Chávez. Then we name cities and streets after them.

18 71 75 **11**		185 61 38	
0 20 72 **0**		254 204 64	
26 42 48 **4**		180 127 100	
4 20 40 **9**		221 183 125	

62 26 29 **27**		72 104 106	
64 27 8 **11**		84 126 160	
55 33 30 **64**		42 48 50	
White		255 255 255	

WILL RYAN'S ELMO AARDVARK Darrell Van Citters, director; Craig Kellman, designer. The "Cinema's Favorite Star," Elmo Aardvark has lately become the Internet's favorite destination. In the scene above, space captain VaVa LaVoom attempts to entice Elmo Aardvark into undertaking a deadly mission. Will he do it? Of course! Wouldn't you? The Flash-animated series is styled after TV cartoons of the 1950s and 1960s.

3 18 25 **0**		227 48 149
14 14 0 **0**		218 208 230
66 50 50 **50**		42 43 44
16 93 100 **5**		203 18 0

26 93 100 **20**		151 15 0
0 90 100 **0**		255 26 0
0 60 10 **0**		247 104 161

25 55 65 **20**		152 83 53
10 10 35 **5**		218 210 148
0 12 55 **0**		254 224 108
30 30 20 **5**		169 151 158
40 0 0 **100**		0 0 0

33 12 10 **7**		159 182 188
83 35 11 **0**		49 114 162
40 6 50 **0**		153 200 123
5 11 27 **0**		241 223 175
5 66 88 **0**		241 86 22

44 21 18 **3**		138 162 167
45 51 74 **40**		84 60 33
8 9 17 **0**		234 225 200
95 62 22 **10**		22 56 112
23 13 52 **0**		193 196 112
0 59 28 **0**		247 106 129

67 19 14 **0**		83 149 170
34 12 29 **0**		165 189 159
89 76 12 **0**		37 39 124
55 41 35 **22**		89 90 97
77 3 23 **0**		59 173 170

31 4 25 **0**	174 214 178
100 22 17 **32**	2 83 107
62 4 68 0	98 179 92
14 0 58 0	219 240 108

30 40 40 **22**	139 105 94
17 17 17 **0**	211 199 189
100 22 17 **32**	2 83 107
0 72 50 **12**	219 64 71

86 0 12 **0**	36 170 187
95 77 5 **0**	24 37 134
0 63 67 0	247 94 57
37 0 18 0	161 218 195
55 74 0 0	118 55 151

46 17 44 **4**	133 165 123
94 46 0 **0**	26 90 166
100 100 0 **0**	23 9 123
10 26 17 **0**	228 183 182
White	255 255 255

Stratodart

ILLUSTRATION Mark. S. Fisher, illustrator. This is one of a series of images from Fisher's *Autopia* collection of wild, customized vehicles. He shows us a futuristic image of his airborne sport utility vehicle as seen from the past. The craft's low-tech metallic surface and mellow color combination send us flying back to 1934. That background green might also have been used in 1939 or 1944, but no, I'll go with my original 1934.

37 11 36 **3**	171 194 157
13 0 27 0	222 242 183
45 45 48 **27**	102 83 74
29 25 39 **5**	171 160 126

20 13 14 **0**	203 205 197
5 0 0 0	242 250 252

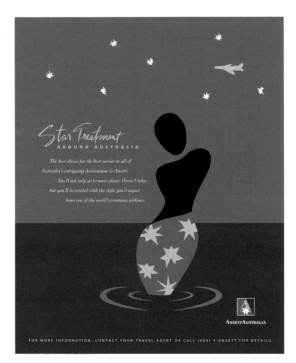

ADVERTISEMENT Larry Vigon, AD; Marc Yeh, designer for Vigon Ellis. The designers chose an Art Deco motif and colors to encourage travel to exotic Australia. For years, Vigon Ellis has created exotic album/CD art for the likes of Eric Clapton, Fleetwood Mac and Counting Crows. Their clients include ABC, A&M Records, Capitol Records, Epson America, Geffen Entertainment and Hard Rock Hotel and Casino.

84 56 5 3		48 75 149
95 91 19 8		25 15 99
3 28 66 0		246 182 75
64 59 6 5		91 77 147

40 0 0 **100**		**0 0 0**
White		255 255 255

0 33 0 0		250 0 23
11 77 0 0		218 60 155
33 55 0 0		169 103 176
28 28 0 0		183 166 208
40 0 0 **100**		**0 0 0**
White		255 255 255

0 66 100 0		255 87 0
55 22 100 0		115 148 24
100 33 22 0		5 104 144
66 88 0 0		94 26 136
40 0 0 **100**		**0 0 0**
White		255 255 255

25 64 100 0		191 81 3
0 0 0 31		176 176 176
32 9 100 28		125 142 12
12 25 50 0		223 182 111
9 7 26 3		224 221 174

0 55 100 0		255 115 0
7 40 20 3		226 145 156
100 0 0 44		0 90 111
60 33 0 0		104 133 189
35 11 65 0		166 193 89
0 11 77 0		255 227 56
40 0 0 **100**		**0 0 0**

100 0 0 **0**		0 160 198
36 34 0 **24**		123 111 150
30 15 26 **0**		179 192 168
100 22 0 **66**		1 43 62
White		255 255 255

0 30 90 **20**		204 143 18
70 15 10 **44**		44 90 113
0 47 30 **3**		242 132 132
0 12 38 **8**		233 205 137
44 55 83 **0**		143 93 38
40 0 0 **100**		0 0 0
White		255 255 255

18 40 88 **0**		208 142 30
30 0 17 **0**		179 225 201
100 20 20 **11**		2 110 137
77 11 33 **0**		61 157 148
15 14 15 **0**		216 207 196
40 0 0 **100**		0 0 0
White		255 255 255

40 10 0 **33**		103 131 149
20 5 10 **5**		193 212 204
60 0 0 **17**		85 165 183
0 70 100 **0**		255 77 0
40 0 0 **100**		0 0 0
White		255 255 255

ILLUSTRATION Mark Frauenfelder, designer. Writer, WIRED columnist and international lecturer on the Internet, Frauenfelder does illustration because "It's a lot more fun than writing. I can listen to music while I draw, and it puts me in much more of a 'flow' state." Indeed, the artist is a music freak who draws much inspiration from the quirky 1950s record album covers of illustrator Jim Flora.

50 0 0 **0**		128 207 226	White	255 255 255
25 0 0 **0**		191 231 241		
100 0 0 **44**		3 90 111		
65 0 100 **0**		89 178 36		

PAINTING Lyle Carbajal, artist. "Picasso was probably my first influence way back when," says Carbajal, "but what really formed my style was Debuffet, Twombly, Basquiat and Appel." Seeming to emerge from the background of this piece are shades of pink, light green and magenta, adding hopeful notes that mitigate its disturbing presence and reveal the solid design behind the artist's approach.

22 100 66 0		196 0 43
0 56 35 0		250 114 119
14 11 9 0		218 215 213
35 41 39 0		165 129 121

20 37 100 0		204 146 6
42 46 10 0		37 79 161
87 27 68 3		34 112 80

0 43 77 0		254 145 47
0 15 60 0		254 217 94
47 0 15 0		136 209 198
37 88 77 22		125 21 27
0 70 100 0		255 77 0
White		255 255 255

81 67 0 15		49 51 130
43 42 0 0		145 125 186
0 45 100 0		255 140 0
36 0 13 0		163 220 207

30 48 0 8		163 110 170
15 31 43 0		214 166 121
7 55 62 0		234 112 71
39 77 86 0		156 49 26
47 0 0 0		136 210 228

47 17 6 0		136 175 200
37 72 0 0		169 64 156
79 0 9 0		55 178 195
0 22 26 0		253 200 168
40 0 0 100		0 0 0
White		255 255 255

0 68 55 0		251 83 76	
20 77 68 0		202 55 51	
20 85 77 37		128 23 22	
0 5 39 0		255 242 152	
40 0 0 100		255 255 255	
White		0 0 0	

28 32 0 0		183 157 203	
10 18 28 0		229 201 165	
21 48 28 0		199 123 137	
72 82 0 0		79 35 141	
40 0 0 100		0 0 0	
White		255 255 255	

30 11 0 7		166 188 210	
0 0 0 27		186 186 186	
39 14 0 34		103 124 143	
0 0 60 67		84 84 34	
40 0 0 100		0 0 0	
White		255 255 255	

54 80 100 11		104 34 4	
17 20 0 23		162 147 170	
3 3 30 0		247 244 175	
5 7 0 4		232 223 234	
40 0 0 100		0 0 0	
White		255 255 255	

ILLUSTRATION Overton Lloyd, illustrator. A superb caricaturist and draftsman, Lloyd wanted to "juxtapose a little bit of my 'rendered' look with a very 'flat' look and end up with something in-between." Adds Lloyd, "The weird thing is that the flat colors vibrating off of each other generate more of a 3-D effect than the rendering of the faces themselves." Strong outlines and bold colors make his work pop indeed from the printed page.

4 3 100 0		245 242 2	
95 89 19 11		24 17 97	
75 16 7 4		64 147 179	
5 60 3 0		234 102 171	

5 27 0 0		239 183 218	
28 0 11 0		184 228 215	
4 3 47 0		245 243 133	
40 0 0 100		0 0 0	

POSTER David Lincoln Brooks, illustrator. Selecting from his deadly palette (see p. 8), Web designer Brooks created this marvelous "fake-o-Deco" graphic, which in French refers to embalming fluid. If one is not too squeamish, the color combination is attractive and seems period-appropriate. Brooks says he's not weird or anything, though. He grew up on a farm, so the sight of entrails doesn't faze him.

5 16 51 **0**		236 208 **131**
0 55 61 **0**		252 113 **70**
51 29 39 **15**		107 122 **110**
31 85 85 **53**		82 16 **13**

10 87 100 **3**		222 32 **8**

60 35 0 **0**		104 130 **187**
100 60 0 **40**		6 39 **92**
26 0 78 **21**		149 178 **51**
15 0 35 **8**		200 221 **150**
60 35 0 **34**		69 85 **123**
White		255 255 **255**

0 18 81 **5**		242 198 **42**
0 87 100 **9**		232 31 **7**
77 66 0 **43**		35 36 **87**
36 27 0 **43**		92 92 **116**
40 33 0 **8**		141 133 **180**

100 17 100 **22**		0 88 **36**
6 0 100 **0**		240 248 **3**
11 22 33 **12**		198 167 **132**
10 0 25 **0**		230 245 **188**
60 0 21 **26**		76 144 **134**
21 47 46 **23**		152 95 **80**

0 48 71 **3**		245 129 **55**
0 100 77 **0**		252 0 **30**
0 0 0 **37**		161 161 **161**
40 0 0 **100**		0 0 **0**
White		255 255 **255**

52 100 0 **10**	113 1 113
100 80 0 **0**	15 33 139
40 100 50 **30**	107 0 44
10 85 85 **0**	229 38 23
19 52 0 **10**	203 115 183
White	255 255 255

0 25 80 **12**	223 168 39
33 0 0 **80**	34 45 47
61 13 78 **0**	100 16 169
7 77 88 **0**	236 58 20
19 10 10 **0**	206 214 211

0 100 100 **0**	255 0 0
0 100 100 **33**	171 0 0
7 57 57 **0**	234 108 79
0 100 100 **60**	102 0 0
White	255 255 255

10 71 0 **0**	222 74 162
0 44 12 **0**	249 145 175
0 33 77 **0**	254 173 50
50 100 0 **0**	129 1 126
33 38 0 **15**	144 119 165
White	255 255 255

©Jean Tuttle 2001

SPOT ILLUSTRATION Jean Tuttle, designer. Aside from being a top-notch illustrator and icon queen, Tuttle has a terrific color sense. I get goosebumps just looking at her swatches (below). With scant use of black, there's a brilliance to her palette of colors, which all seem harmonious. Tuttle is very professional, too. If she has an illustration of a building that's slightly too short for your page, she'll even stretch it out for you.

50 70 30 **59**	53 26 46
50 100 30 **10**	116 0 79
25 100 90 **0**	190 0 13
10 60 100 **0**	230 97 1

80 30 40 **0**	54 121 123
50 10 30 **0**	128 184 159
20 20 50 **0**	203 187 114
15 10 10 **0**	216 217 212

POSTER Leslie Cabarga, illustrator. This design started out in too-predictable psychedelic colors. Then I began playing with my palette of basic pink, yellow and blue in Adobe Photoshop. I slid the colors over to the greenish side of the color balance scale which made them more funky and weird. The poster promotes my set of six psychedelic fonts called *Peace* and *Love*. The dingbats in back are part of the font set.

CMYK	RGB	CMYK	RGB
0 68 17 0	247 84 140	25 100 41 26	139 0 55
42 4 29 0	148 204 168	20 0 68 0	204 233 86
0 21 30 0	253 202 160	80 13 83 0	52 142 70
6 3 100 0	240 240 2		

35 0 15 15	142 188 173
0 50 88 0	254 127 24
7 70 60 30	164 53 47
0 80 60 0	250 52 61
40 0 0 100	0 0 0
White	255 255 255

9 90 0 0	221 26 138
0 4 100 0	255 245 0
40 0 0 100	0 0 0
White	255 255 255

5 5 20 22	188 185 154
7 0 26 47	125 131 99
7 5 0 10	213 213 221
53 35 41 54	55 60 55

0 45 60 0	252 141 79
0 45 60 25	189 105 59
20 71 71 40	121 41 29
40 0 0 100	0 0 0
White	255 255 255

CMYK				RGB		
74	23	0	0	70	143	193
42	27	3	0	148	157	197
37	60	40	5	152	83	99
81	72	35	22	43	38	79
50	3	15	0	129	200	194
3	29	59	0	245	179	90

CMYK				RGB		
10	43	66	20	183	112	55
37	43	76	25	120	91	40
35	5	15	5	158	199	188
11	5	22	5	215	220	181
30	70	50	30	125	48	58
100	50	0	0	10	80	161

CMYK				RGB		
49	26	100	0	130	146	20
16	18	19	0	213	196	183
13	80	100	0	222	48	0
40	0	0	100	0	0	0
White				255	255	255

CMYK				RGB		
5	0	70	0	242	249	78
70	4	100	0	77	165	37
50	40	0	30	90	88	131
0	55	100	0	255	115	0

POSTER Leslie Cabarga, designer. Where can you find a variety of cool fonts ranging from retro—like the 60s fonts, opposite page, and the 30s fonts, above—to ultramodern styles, plus original stock art all displayed in thrilling Flash movies? Why, at my Web site, www.flashfonts.com, of course. I created this poster in the old German style for Agfa-Monotype, for which I originally designed the Angle family of fonts. I threw some meaningless lines and circles into the poster to jazz it up.

CMYK				RGB				CMYK				RGB		
4	6	16	3	237	229	200		76	27	16	3	63	127	158
0	10	100	0	255	230	0		15	100	85	33	144	0	12
0	50	100	0	255	127	0		0	77	100	0	255	60	0
15	100	100	0	217	0	0		40	0	0	100	0	0	0

EUROP

I love Paris in the springtime: the 7C/5M/7Y/0K of the dogwood blossoms, the 0C/22M/100Y/0K of the taxi cabs and the 0C/100M/100Y/10K of those Stella Artois awnings. Of course, as a carb freak, all of Europe, with its incredible pastries and chocolates, is heaven. ■ And there's a wealth of great color to be found in Europe, too. The graphic arts enjoy wide acceptance, and their importance became well established long before the same was true in America. Sumptuous portfolios of poster reproductions were being issued in France at the turn of the century and Germany's *Das Plakat* (The Poster) followed in 1910. A means existed, therefore, to readily spread visual ideas throughout the European continent and abroad. Despite such sharing, each of the European nations put its own spin on current styles. German colors tend to be cooler, French colors are warmer and in Italy and Spain colors get much warmer in keeping with those countries' relative climates. ■ A comparison of Europe's greatest architects of the Art Nouveau period provides telling clues to the design characteristics of each nation. Victor Horta was a pragmatic dreamer whose work, despite its technical brilliance, was destined to share the ignominy that is Belgium. Hector Guimard's work overflowed with a superfluity of emotional vulnerability masked by French conceit. Joseph Maria Olbrich was brilliant in a detached, methodical way, his heart constrained by German rigidity. Antoni Gaudi was a hot-blooded cuckoo, as contradictory as the Spanish Catholicism he embraced. ■ All in all, European color is "deep." It's rich, saturated, mature and wonderful.

EAN

OLOR

TILE FLOOR When we think of Spanish tile, we usually think of warped tiles in too-bright colors with big rounded corners and dog footprints in them. No, those are Mexican tiles. These 1920s catalogue samples from the Barcelona factory of Hijos de Juan Vila show refinement and elegance, a good pavement (as they used to call tile floors) for dark, worm-holed wood furniture with spiral-carved posts.

CMYK	RGB
24 24 35 3	187 170 138
27 22 69 6	175 165 70
35 31 45 10	149 136 105
7 11 19 0	236 221 193

CMYK	RGB
14 34 0 0	216 160 206
0 25 50 0	253 191 111
7 38 100 0	237 153 1
50 100 0 18	106 1 103
40 0 0 100	0 0 0
White	255 255 255

CMYK	RGB
5 0 7 13	211 218 204
19 11 0 17	171 176 92
37 66 57 26	119 55 55
44 28 31 33	97 103 98
47 83 72 63	50 13 16

CMYK	RGB
14 81 88 10	197 41 18
15 30 57 16	181 141 79
0 18 55 5	241 199 99
65 11 27 44	51 94 90
9 6 9 0	232 232 221

CMYK	RGB
20 17 100 0	204 192 9
73 81 18 0	76 36 117
25 14 12 0	191 198 198
White	255 255 255

12 24 50 0		223 184 112
5 50 82 0		241 124 36
62 9 40 9		89 157 127
50 100 34 0		128 0 83
40 0 0 100		0 0 0

85 59 0 35		31 47 103
18 15 10 9		189 184 187
7 38 100 0		237 153 1
59 0 9 0		106 198 204
White		255 255 255

TILE FLOOR Even with some brighter accent colors, there is something laid-back about the combination of colors in these patterns. The designers knew that their work would serve not as the focus of the room or hall, but to create the setting for its accoutrements. Still, the individual colors of dusty orange, lilac and "national school-bus yellow" are a surprise, almost too modern-looking for the period.

15 15 25 0		216 205 173		40 40 53 27		112 93 70
21 37 63 11		178 131 70		53 48 52 54		55 48 42
7 52 74 0		235 119 50		4 33 87 0		244 168 30
25 42 18 14		182 129 153				

0 25 50 0		253 191 111
37 78 57 26		119 36 50
11 27 14 0		225 179 186
25 14 12 0		191 198 198
65 30 27 0		91 132 145

100 14 52 0		1 127 114
72 28 100 0		71 122 29
36 18 31 0		163 179 153
3 3 17 0		247 244 207
40 0 0 100		0 0 0

100 49 58 **0**	3 75 84
0 18 60 **0**	254 209 93
25 10 33 **0**	191 207 158
100 65 0 **0**	13 56 150
50 100 89 **11**	113 0 12
0 48 100 **12**	224 116 10
40 0 0 **100**	0 0 0
White	255 255 255

0 69 63 **0**	251 80 62
9 28 100 **0**	232 176 2
29 11 42 **28**	131 144 99
40 0 0 **100**	0 0 0
White	255 255 255

BOOK COVER I love the contrast between the grayed-down lady and the boldly outlined rose and quill, which might have something to do with the pen being mightier than the sword. In this case, it's at least "brighter" than the sword. The cover painting may have predated the book because the grafted-on type (actually hand-lettering) is more modern than the Art Nouveau-derived style of the painting.

18 82 89 **3**	202 42 17
15 24 45 **0**	216 182 122
30 24 34 **0**	179 171 143
34 33 40 **18**	137 121 102

16 74 64 **0**	212 63 53
15 36 73 **0**	216 153 59
40 0 0 **100**	0 0 0

100 70 0 **0**	14 49 146
0 30 100 **0**	255 179 0
10 10 10 **33**	171 171 171
White	255 255 255

30 25 0 **0**	178 171 210
65 50 0 **0**	93 96 171
0 0 79 **0**	255 255 54
26 52 0 **0**	185 111 180
White	255 255 255

0 64 70 0		252 93 51
100 8 30 8		1 130 138
0 59 66 44		141 59 34
0 9 16 0		254 231 204
40 0 0 100		0 0 0

12 10 33 0		223 219 160
100 49 58 0		3 75 84
31 26 100 31		122 112 9
39 20 23 10		155 173 167
40 0 0 100		0 0 0

0 31 50 25		189 132 80
0 14 50 6		239 206 111
17 0 43 20		170 190 115
15 22 31 18		177 154 126
90 24 55 50		14 59 51
7 4 15 0		237 238 210

0 32 72 0		254 173 60
24 59 100 0		194 93 9
24 77 100 35		125 36 1
41 28 0 20		120 126 162
7 10 0 0		236 224 239

OLIVE OIL TIN Here is a clever packaging concept that combines a simple, legible modern design with traditional, Spanish-style decorative motifs. But the really brilliant part of the whole thing is the unusual and subtle yellow color in the center, which upon closer inspection is just about the exact color of olive oil.

9 10 100 7		216 205 3
100 80 0 0		15 33 139
75 9 72 18		53 127 69
40 13 80 30		108 128 41

86 19 0 0		41 141 191
3 83 89 0		246 44 17
White		255 255 255

ART DECO DESIGN What the designer of these Art Deco motifs would have given for the easy step-and-repeat of modern computer graphics! Sure, he might have said, "Cet ordinateur est très bien, mais il ne remplacera jamais l'apprentissage manuel pour le fondamental du dessin mécanique et géométrique." But of course, that was everybody's initial reaction to the computer, and *now* look!

70 60 10 5		78 72 139
27 95 67 7		171 15 41
0 90 75 0		252 27 35
32 38 33 13		150 120 117

7 20 14 0		235 199 195
13 65 55 3		84 75 136
27 77 88 44		104 29 12
40 0 0 100		0 0 0

88 66 11 0		41 59 137
0 30 12 7		223 167 176
22 55 12 0		196 107 158
55 5 17 0		116 190 187
0 12 25 0		254 223 179
40 0 0 100		0 0 0

0 7 100 0		255 237 0
25 11 80 30		134 141 39
10 0 40 15		196 208 129
40 10 5 15		130 166 180
100 77 0 33		10 25 95
10 10 10 10		219 228 240

66 66 0 5		88 64 149
60 30 0 0		107 140 193
33 11 77 0		171 194 65
40 0 0 100		0 0 0

11 25 50 0		226 183 111
40 60 70 25		114 63 43
90 60 0 0		36 59 156
60 0 50 30		72 134 89
40 0 0 100		0 0 0
White		255 255 255

CMYK				RGB		
17	7	7	**0**	212	222	221
88	30	0	**0**	37	121	181
80	80	40	**0**	57	35	88
40	15	20	**20**	123	147	141

CMYK				RGB		
15	87	50	**0**	213	34	71
0	66	100	**7**	237	81	0
0	37	25	**0**	251	162	156
50	19	17	**0**	128	167	176
25	35	80	**30**	134	104	33
27	5	15	**0**	186	217	201
100	77	44	**22**	6	27	66

CMYK				RGB		
40	50	60	**5**	145	100	74
0	25	50	**0**	253	191	111
0	80	75	**0**	252	52	39
30	20	60	**20**	143	143	75
3	5	15	**0**	247	239	210
40	0	0	**100**	0	0	0

CMYK				RGB		
0	5	80	**0**	255	242	50
55	0	50	**0**	115	196	127
22	22	7	**22**	154	143	158
20	50	70	**40**	122	70	36
40	0	0	**100**	0	0	0

ART DECO DESIGN This pattern brings to mind a scene out of Fritz Lang's "Metropolis" (1927) or Chaplin's "Modern Times" (1936). There is a feeling of movement here, as though one is about to be macerated by the machinery of progress. The color combination looks industrial, except for the mustard yellow and burnt sienna, which bring to mind the wiener commercials of Oscar Mayer (c. 1976).

CMYK				RGB		
13	49	100	**4**	213	117	2
27	84	84	**40**	111	22	15
0	8	37	**0**	254	235	155
35	35	42	**11**	147	127	106

CMYK				RGB		
73	27	31	**23**	55	101	107
40	0	0	**100**	0	0	0

DECO MOTIF V. Boberman Pochoir, designer. This original gouache painting, with its cold palette and abstract geometrical motif, embodies the essence of the Arts Decoratifs style. I picked it up, along with a bunch of Art Deco prints at a little bookstall along the Seine. Colors like these, both cool and evocative of machinery, were considered modern compared to, say, an earlier image by Auriol, opposite page.

30 19 20 0	179 183 176
42 28 34 15	126 130 118
5 7 12 0	241 233 214
19 60 60 20	164 76 58

40 0 0 100	0 0 0

0 15 10 0	253 217 213
0 50 37 0	250 129 119
20 40 0 25	150 107 147
77 40 0 0	64 110 177
40 10 5 25	115 146 158
27 5 6 7	173 202 205

70 35 0 0	81 123 184
45 45 0 25	105 88 137
0 20 27 25	189 153 125
60 5 15 10	93 168 170
0 6 7 7	236 223 214
40 0 0 100	0 0 0

60 50 44 0	104 96 104
0 0 85 15	217 217 33
45 0 50 15	119 176 108
10 0 0 5	218 233 237
80 30 3 30	39 88 126

0 15 10 0	253 217 213
0 50 37 0	250 129 119
20 40 0 25	150 107 147
77 40 0 0	64 110 177
40 10 5 25	115 146 158
27 5 6 7	173 202 205
40 0 0 100	0 0 0

55 40 0 **20**	94 98 148
0 35 15 **0**	251 167 179
25 0 25 **0**	191 230 184
15 18 5 **15**	183 168 182
3 3 10 **0**	247 244 225

40 0 20 **25**	115 161 142
22 50 100 **50**	127 63 0
0 0 0 **25**	191 191 191
40 0 0 **100**	0 0 0

Noël 1922

Paris
44, Rue des Abbesses
les meilleurs vœux
de M. et Madame George Auriol

XMAS SELF-PROMO George Auriol, designer. Christmas at the Chateau Auriol was a somber affair, but really, colors like these were then thought classy. Auriol is now mainly remembered as the designer of an eponymous font, a cross between Cooper Black and Stencil, shown above in casual, hand-lettered form. Auriol the typeface, along with Cooper and Parsons, is one of the great warm-and-fuzzy fonts of the 1920s.

24 25 34 **16**	162 145 120
15 20 34 **5**	205 182 141
45 13 23 **37**	89 115 108
20 38 72 **15**	173 123 51

45 25 19 **58**	59 66 71

33 11 100 **4**	164 184 16
40 11 40 **20**	123 152 112
65 17 44 **44**	51 87 71
0 7 10 **0**	254 237 222

0 50 44 **0**	251 128 107
40 60 70 **0**	153 85 57
10 0 10 **50**	115 122 112
0 20 17 **0**	253 205 191
13 10 13 **10**	200 197 186
8 0 11 **0**	235 247 223

DECO MOTIF There's nothing like a French plum...print. A stone lithograph like this—with delicious colors like these—could have come from any country and still appear as sweet. There's nothing particularly French about this print. It was, however, a genuine *produit de France*, and this is the French color section, so there you have it.

23 14 24 **0**		196 199 174	
27 44 50 **25**		138 95 74	
22 34 44 **6**		186 144 110	
21 76 93 **7**		186 52 14	

39 24 88 **38**		97 99 25	
18 14 67 **6**		196 190 76	
49 27 47 **66**		44 49 39	
3 3 9 **0**		247 244 227	

0 44 88 **0**		254 140 25
50 70 0 **10**		116 58 141
40 0 0 **100**		0 0 0
White		255 255 255

0 66 100 **0**		255 87 0
0 15 44 **0**		254 217 132
0 30 100 **0**		255 179 0
33 100 70 **0**		170 0 38
40 0 0 **100**		0 0 0
White		255 255 255

0 45 100 **0**		255 140 0
88 22 0 **0**		36 135 188
0 100 80 **0**		252 0 25
40 0 0 **100**		0 0 0
White		255 255 255

80 55 0 **0**		61 83 164
0 100 80 **0**		252 0 25
7 10 17 **15**		201 190 169
80 80 0 **66**		20 13 48
40 20 0 **0**		153 174 211
White		255 255 255

66 42 0 **20**		73 90 143
0 8 **70** 0		255 235 74
0 22 30 3		245 193 154
77 22 100 **30**		42 90 23
11 27 100 **25**		170 132 2
40 0 0 **100**		0 0 0
White		255 255 255

40 28 0 **12**		134 138 178
6 13 22 0		239 217 184
0 27 60 0		254 186 86
20 71 90 0		203 68 19
16 40 88 0		213 142 29
40 0 0 **100**		0 0 0

WEB SITE DESIGN It's all about the Louvre, isn't it? And yet on those days when the lines in front of Pei's pyramid are too long, many have discovered another great Paris Museum—the Musée d'Orsay. I can't explain it, but my whole life I've liked being in dark places where I can look out on illuminated places. Maybe that's what attracted me to this Web page with its rich, dark maroon background "illuminated" by spots of golden yellow and a purpley-blue to swoon over.

85 35 **0** **14**		38 98 153
15 9 8 **15**		184 186 185
11 15 33 6		213 195 147
30 80 80 0		178 45 32
40 0 0 **100**		0 0 0
White		255 255 255

11 100 74 **0**		224 0 33
56 9 8 **28**		82 132 144
40 79 0 0		152 48 148
15 9 8 **15**		184 186 185
40 0 0 **100**		0 0 0
White		255 255 255

49 36 0 **0**		131 134 190
28 83 82 **50**		91 19 14
0 45 100 0		255 140 0
15 80 100 4		208 46 1

20 70 100 **20**		166 57 9
40 0 0 **100**		0 0 0
White		255 255 255

71 9 50 **11**		67 145 107
19 0 27 **0**		207 236 181
18 0 57 **0**		209 235 113
82 52 12 **46**		29 46 80
32 100 89 **11**		154 0 12
White		255 255 255

12 10 12 **15**		190 187 177
100 43 14 **0**		8 89 147
27 9 41 **25**		136 151 103
39 20 23 **55**		70 78 75

ITALIAN GLASS (c. 1928) Stained glass is appealing to me, not only because the light-enhanced colors are like pre-RGB, but because of the heavy outline effect caused by the lead channels. Alfons Mucha, Winsor McCay and F.G. Cooper were three (nonstained-glass) artists who made delicious use of the bold, decorative outline stroke. Hey, maybe Mucha's heavy stroke actually *was* inspired by stained glass.

18 18 16 **0**		208 195 189
16 89 100 **0**		214 27 0
29 74 67 **49**		92 30 27
55 21 64 **15**		98 130 75

31 25 85 **8**		162 151 39
54 34 65 **50**		59 64 39
40 0 0 **100**		0 0 0

0 100 83 **0**		253 0 22
75 20 100 **12**		56 117 29
31 4 75 **9**		160 192 65
29 25 16 **0**		180 170 178
18 44 79 **0**		208 132 45

7 100 87 **24**		179 0 13
8 17 100 **0**		235 204 2
5 5 35 **0**		242 237 160
21 26 41 **0**		200 173 129
0 15 35 **0**		254 217 153
40 0 0 **100**		0 0 0

69 0 27 **0**		79 185 167
39 15 21 **8**		144 170 161
92 72 0 **11**		29 142 130
64 73 23 **0**		96 53 117
White		0 0 0

9 12 100 **0**		232 215 3
0 9 10 **16**		213 195 84
49 0 76 **0**		130 199 75
65 21 100 **0**		89 140 28
0 5 32 **0**		255 242 169
50 77 69 **30**		90 33 35

ITALIAN GLASS The best stained glass is designed so that the leading conforms to the contours of the drawing. The few artists nowadays who can still make as nice a drawing as the one above don't do windows. They're probably drawing graphic novels called *Dred-Spumk*, or something. Unfortunately, too, many of the colors and textures that made the glass on these pages so exquisite are no longer sold.

50 20 24 **5**		121 156 154	35 24 74 **14**		143 141 56
23 15 21 **0**		195 198 179	68 22 67 **60**		52 88 42
15 37 53 **0**		215 151 98	40 0 0 **100**		0 0 0
10 75 89 **0**		229 62 19			

0 14 0 **0**		253 219 237
0 36 19 **19**		204 133 138
32 73 100 **19**		140 48 2
0 0 0 **22**		199 199 199
40 0 0 **100**		0 0 0

0 78 62 **0**		251 58 59
12 94 75 **18**		181 16 28
43 94 63 **27**		106 12 36
9 12 100 **0**		232 215 3
0 23 31 **0**		253 197 156
40 0 0 **100**		0 0 0

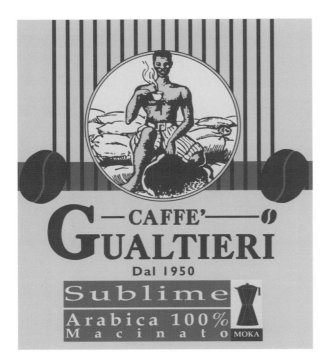

COFFEE PACKAGING Barbara Sentimenti, designer for Mainstreet.it. The aim of this packaging project for Modena Coffee was to "transmit the warmth and tradition of this classic blend," explains Sentimenti. "The chosen colors are the typical ones for this kind of product: black, yellow–gold and red. The graphic layout had to be rich and essential at the same time."

6	14	94	0		240	213	19
13	100	72	3		212	0	34
29	69	68	46		97	38	30
10	9	19	0		229	223	194

0	5	50	0		255	242	124
68	11	100	0		82	155	33
23	0	79	0		196	229	61
0	55	16	0		248	117	155
0	15	30	10		229	196	149
40	0	0	100		0	0	0

0	100	100	14		219	0	0
100	24	45	0		2	114	118
43	24	0	0		145	163	205
0	25	30	0		253	192	156
25	25	31	0		190	172	150
40	0	0	100		0	0	0
White					255	255	255

29	20	0	7		167	170	201
90	63	0	12		33	56	175
45	23	0	35		89	104	130
40	0	0	100		0	0	0
White					255	255	255

64	16	24	16		79	134	136
11	29	87	0		227	172	32
5	13	55	0		241	217	108
30	26	33	0		179	167	144
7	72	100	17		197	57	0
40	0	0	100		0	0	0

75 0 50 **0**		65 175 126
81 5 0 **0**		46 167 203
45 0 73 **19**		114 48 125
31 26 14 **65**		61 58 63

79 0 100 **0**		54 161 43
0 100 100 **0**		255 0 0
100 69 0 **0**		14 50 147
White		255 255 255

0 15 0 **0**		253 219 237
25 42 43 **13**		165 116 98
100 41 60 **11**		2 76 77
40 0 0 **100**		0 0 0

12 20 46 **0**		223 194 124
90 40 60 **22**		23 72 67
51 23 34 **12**		152 169 156
White		255 255 255

POMPEII FRESCO Look what you can find under lava! It's even more surprising to see the crazy, almost psychedelic colors used by the ancients. Pompeian rooms, with scant if any windows, were decorated to create a sense of expanded space through the use of such motifs as elegant foliage, trailing tendrils, arabesques, trellises and dimensional architectural details that may have been the first trompe l'oeil.

32 69 80 **20**		138 55 29
38 44 13 **0**		158 123 164
43 30 10 **0**		145 150 181
49 18 68 **7**		121 153 76

3 51 45 **0**		243 125 104
0 5 4 **0**		254 242 239
40 0 0 **100**		0 0 0

80 33 0 **0**		56 121 181
0 62 0 **0**		246 100 176
26 100 0 **0**		183 1 126
0 42 100 **0**		255 148 0
0 0 89 **0**		255 255 29
40 0 0 **100**		0 0 0

10 27 36 **8**		210 165 129
29 32 0 **0**		181 156 203
44 72 81 **0**		143 58 35
15 78 56 **8**		197 50 63
0 10 25 **0**		254 230 182
40 0 0 **100**		0 0 0

POSTER STAMP Before enlargement, this poster stamp was only thumbnail size. The incredible detail in the hand stippling of this stone lithograph becomes all the more amazing when blown up. The colors are amazingly beautiful, too. The puce and pink beard stippling, as well as the background stippling, create a luminescence and perception of depth that unfortunately can't be captured in our flat colors below.

0 85 100 **0**		255 39 0
29 72 63 **47**		95 33 32
74 35 22 **22**		255 245 197
4 25 39 **0**		255 130 14

13 30 91 **0**		253 177 114
42 19 63 **18**		200 194 149
59 33 51 **34**		62 108 109
40 0 0 **100**		251 113 83

21 9 100 **0**		201 209 11
24 19 14 **0**		193 188 190
16 7 36 **4**		204 212 149
40 0 0 **100**		0 0 0
White		255 255 255

100 85 0 **0**		17 25 135
23 7 100 **0**		196 211 12
0 36 72 **0**		254 163 58
0 13 26 **0**		254 222 176

0 5 35 **0**	255 242 162
0 52 100 **0**	255 122 0
0 100 83 **33**	169 0 15
50 72 13 **19**	104 48 109
42 0 37 **0**	148 211 154

10 0 4 **3**	223 238 234
40 5 20 **5**	145 194 176
100 50 0 **7**	9 75 149
40 0 0 **100**	0 0 0

80 0 60 **35**	33 109 72
0 55 60 **0**	252 116 74
0 85 35 **10**	223 37 86
0 10 80 **0**	255 230 49
3 5 10 **0**	246 239 223
40 0 0 **100**	0 0 0

0 10 80 **0**	255 230 49
19 20 0 **40**	123 114 132
3 5 10 **0**	246 239 223
40 0 0 **100**	0 0 0

PRINT There's something so unpleasant-looking about this baby that I would not have selected this illustration, from a portfolio of art prints, if I wasn't so fascinated with its colors. I even took the liberty of cleaning the kid up a bit by playing Photoshop art director after-the-fact, but the big question is, who's going to clean up that spilled milk…or is it milk?

11 9 0 **0**	226 223 238
40 45 49 **14**	131 101 86
33 77 59 **29**	121 37 46
40 0 0 **100**	0 0 0

0 5 70 **0**		255 242 75
10 100 70 **11**		223 0 34
10 100 70 **40**		136 0 23
22 15 22 **10**		179 179 61
40 0 50 **30**		108 149 89
70 50 25 **0**		81 93 132
25 33 22 **75**		47 39 40

16 44 93 **0**		214 134 20
0 8 76 **6**		240 221 56
10 100 70 **53**		106 0 18
9 0 0 **0**		229 241 245
43 25 25 **10**		131 143 142

WALLPAPER DESIGN Having paper like this on your walls would probably drive you crazy after six months—unless you're already crazy, in which case, they say pink is calming and subduing (hence its suspicious use in the rooms of little girls). Such wallpaper may in part have prompted an American architectural writer in the 1920s to comment on "the appalling conditions under which the modern German must live."

7 42 29 **0**		233 145 142
7 84 75 **0**		234 42 37
42 20 0 **4**		142 166 202
75 50 0 **25**		52 69 126

7 30 70 **0**		236 174 67
27 50 70 **20**		139 84 45
30 73 65 **37**		89 30 29
40 0 0 **100**		0 0 0

0 66 S **0**		255 87 0
77 0 0 **11**		53 162 188
22 7 S **0**		199 213 12
5 8 33 **0**		241 230 163
44 90 S **0**		142 20 1
40 0 0 **S**		0 0 0

27 4 33 **0**		186 218 162
60 15 11 **7**		96 155 174
77 66 11 **11**		59 56 124
14 42 13 **0**		215 141 172
33 100 44 **0**		169 0 71

0 100 100 **11**	227 0 0
25 75 23 **29**	133 43 85
22 35 70 **10**	179 136 58
10 100 100 **40**	138 0 0
100 52 76 **43**	1 39 33

12 22 0 **7**	206 177 206
10 50 100 **10**	207 109 1
100 22 0 **7**	3 116 169
10 10 10 **10**	184 1 80
15 5 0 **0**	217 229 240

COVER DETAIL Max Bittrof, designer. This 1927 cover illustration from the influential German magazine *Gebrauchsgraphik* uses an abstracted collage of machine parts in both warm and cool grays that are intended to soothe us, then knocks us down with brilliant red. Nowadays, this illustration—perfect for an Adobe Illustrator rendering—would show printed circuits, computer keyboards and silicon chips.

0 4 17 **0**	255 245 208
24 32 42 **6**	181 147 115
38 34 27 **8**	145 132 136
48 49 51 **36**	85 67 60

0 80 100 **0**	255 51 0
26 88 100 **27**	138 21 0
40 S	0 0 0

11 6 24 **0**	227 230 185
100 22 22 **15**	2 103 129
44 63 0 **0**	143 80 164
0 66 100 **7**	237 81 0
100 66 0 **70**	2 17 45

0 5 55 **0**	255 242 112
70 11 17 **0**	79 166 176
11 100 80 **0**	225 0 25
77 80 44 **0**	64 36 83

23 0 6 **8**		181 214 **210**
29 0 9 **37**		114 143 **138**
8 17 0 **50**		116 103 **114**
50 77 66 **25**		96 36 **41**
40 0 0 **100**		0 0 **0**

17 35 91 **0**		212 153 **25**
0 0 0 **27**		186 186 **186**
0 0 32 **21**		201 201 **136**
11 8 0 **41**		133 133 **141**
40 0 0 **100**		0 0 **0**
White		255 255 **255**

WEB PAGE DESIGN Dirk Uhlenbrock, Signalgrau.com. "I'm very interested in the arts," says Uhlenbrock, one of Germany's best Web designers. "I love the work from the early 20th century—the Dada stuff, Paul Klee, Max Ernst, Kurt Schwitters. Music is also a very strong catalytic converter and my comic book background is a huge pool for influences." Yeah, sure, the usual influences, but Signalgrau does it so damned good.

62 0 28 **0**		98 192 **168**		26 67 100 **39**		116 45 **1**
18 12 96 **3**		202 199 **19**		89 56 0 **0**		38 76 **159**
31 27 100 **19**		143 129 **10**		3 3 93 **0**		247 243 **22**
60 33 27 **17**		86 109 **120**		40 0 0 **100**		0 0 **0**

11 8 0 **41**		133 133 **141**
0 35 47 **21**		199 131 **88**
9 19 49 **0**		230 199 **117**
40 0 0 **100**		0 0 **0**
White		255 255 **255**

0 100 70 **27**		183 0 **28**
0 48 26 **0**		250 134 **144**
0 0 0 **60**		102 102 **102**
40 0 13 **0**		153 216 **205**
15 32 44 **0**		215 163 **119**
40 0 0 **100**		0 0 **0**
White		255 255 **255**

7 66 100 **0**			237 84 0	
0 46 100 **0**			255 138 0	
0 84 100 **30**			179 30 0	
0 0 0 **40**			153 153 153	
30 30 23 **57**			75 68 69	
100 19 0 **0**			3 130 184	
40 0 0 **100**			0 0 0	
White			255 255 255	

0 20 40 **0**			253 204 138	
0 39 78 **0**			254 156 45	
70 16 16 **14**			68 134 149	
42 8 8 **6**			140 186 195	
40 0 0 **100**			0 0 0	

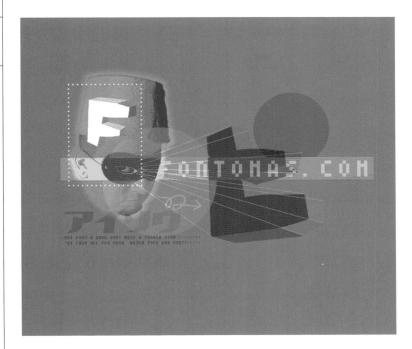

WEB PAGE DESIGN Dirk Uhlenbrock, Signalgrau.com. According to Uhlenbrock, coming up with colors is like composing music, "sitting at the piano and trying to create a song using the right chords related to the hook line. Sometimes I start with just a plain Photoshop canvas filled with a single color." Aside from their client work, Dirk, and his brother Knut run Fontomas.com, a font site notable, in part, for its fearless use of color.

27 84 0 **0**		181 40 144		14 44 100 **4**		210 128 3
26 100 72 **20**		150 0 28		0 12 93 **0**		255 224 20
27 52 0 **0**		183 111 180		23 79 100 **12**		172 43 1
0 91 40 **0**		247 26 83		White		255 255 255

0 3 66 **0**			255 247 86	
55 12 0 **0**			116 178 212	
78 52 0 **0**			63 87 166	
0 87 0 **0**			242 38 144	

33 50 80 **30**			120 76 31	
50 5 9 **9**			116 177 185	
0 20 9 **9**			227 185 189	
27 20 9 **9**			168 167 180	
19 3 5 **5**			196 218 217	
40 0 0 **100**			0 0 0	
White			255 255 255	

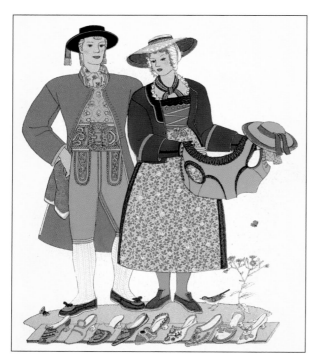

TYROLEAN FOLK COSTUME By 1937, Austria had fallen under the German Reich. These Austrian book illustrations advocated that the "cultural treasure" of such traditional garb (c. 1790s) be revived for everyday streetwear, as current fashions had become "impoverished and sober.... To renew such fashions would add color and liveliness to life." The female figure above apparently had a pre-Imeldaian fondness for footwear.

21 77 69 **0**	199 55 49		47 19 29 **19**	110 137 125	
66 73 4 **34**	61 35 95		32 27 60 **36**	110 103 58	
14 37 82 **0**	218 151 41		5 23 33 **0**	240 193 150	
4 44 49 **0**	242 142 101				

29 100 100 **59**	74 0 0
10 33 37 **0**	228 165 133
54 25 0 **0**	119 153 199
0 0 25 **0**	255 255 191
White	255 255 255

0 0 0 **67**	84 84 84
17 13 0 **13**	184 181 200
0 9 100 **11**	227 206 0
0 4 22 **0**	255 245 195
0 100 100 **0**	255 0 0
40 0 0 **100**	0 0 0
White	255 255 255

100 72 0 **0**	14 45 145
21 21 84 **25**	150 136 33
0 60 100 **0**	255 102 0
40 0 0 **100**	0 0 0
White	255 255 255

0 45 100 **4**	245 135 0
31 71 59 **8**	161 60 63
74 6 100 **18**	54 129 32
0 0 0 **12**	224 224 224
40 0 0 **100**	0 0 0
White	255 255 255

0 100 0 **0**		240 2 127
33 17 100 **0**		171 179 15
14 12 0 **29**		155 151 165
40 0 0 **100**		0 0 0
White		255 255 255

5 59 39 **17**		197 87 91
0 90 90 **35**		165 16 8
15 59 81 **21**		170 78 28
4 14 19 **5**		232 205 181
40 0 0 **100**		0 0 0
White		255 255 255

25 85 66 **18**		155 29 41
45 16 64 **8**		129 159 83
0 14 60 **5**		241 208 90

0 76 50 **0**		249 63 79
0 76 52 **38**		155 39 47
0 0 0 **15**		217 217 217
0 0 0 **53**		120 120 120
40 0 0 **100**		0 0 0

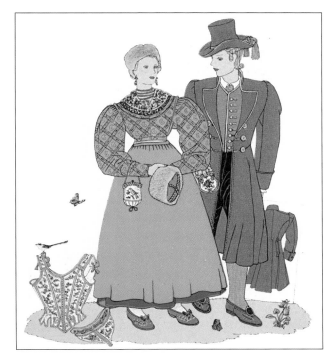

TYROLEAN FOLK COSTUME Each page from *Trachten der Alpenlander* was printed in six to eight colors—different colors for each page! I surmise the artist was a woman, both for the loving attention to every seam and because of the effeminately drawn male figure. Sorry, but I've always noticed this tendency of *some* female artists. And just look at those skivvies! Victoria's Secret, take note.

0 56 100 **0**		255 112 0		3 22 44 **0**		245 197 127
26 25 58 **31**		130 117 66		3 27 84 **0**		246 184 37
42 20 0 **9**		135 157 191		40 0 0 **100**		0 0 0
33 15 34 **19**		139 153 122		White		255 255 255

ORNAMENT BOOK Julius Klinger, designer. This selection from a 1909 portfolio is the work of Klinger, Austria's greatest and most prolific poster designer (and he could really draw!). In Klinger's own words, "The backs of our sober designs are smeared with paste, but on their fronts we build up our world picture with maddening conscientiousness [to] preserve our work for all time." (Which might have sounded coherent before translation.)

CMYK	RGB	CMYK	RGB
35 36 11 7	154 132 163	57 35 16 15	95 111 137
54 35 54 23	91 99 75	3 0 15 0	247 252 216
27 72 54 20	147 51 60		
11 43 47 3	217 135 102		

CMYK	RGB
0 87 100 0	255 34 0
90 23 36 0	29 125 132
20 25 20 20	162 141 138
40 0 0 100	0 0 0
White	255 255 255

CMYK	RGB
3 3 0 20	197 195 199
0 17 50 0	254 212 116
10 50 15 10	203 112 144
87 86 0 0	46 26 136
0 70 100 0	256 77 0

CMYK	RGB
30 56 59 25	133 74 57
5 70 9 0	234 78 150
0 10 21 0	254 228 190
73 50 0 0	75 93 169

CMYK	RGB
14 33 36 0	217 163 135
30 62 60 13	155 74 62
0 0 0 27	186 186 186
0 4 100 0	255 245 0
40 0 0 100	0 0 0
White	255 255 255

5 17 22 **30**		169 146 127	
8 14 13 **5**		222 202 193	
67 12 18 **50**		43 83 87	
45 45 0 **0**		141 118 183	
White		255 255 255	

12 4 7 **0**		224 234 227	
33 17 100 **19**		139 146 12	
7 37 86 **12**		208 137 28	
54 4 9 **6**		111 183 191	
22 7 0 **46**		107 117 126	
40 0 0 **100**		0 0 0	

0 100 100 **0**		255 0 0	
5 11 100 **0**		242 222 2	
80 33 0 **25**		42 90 136	
45 18 0 **7**		131 162 196	
White		255 255 255	

50 70 0 **0**		129 64 156	
22 26 0 **0**		197 174 212	
63 0 12 **0**		95 193 197	
0 0 0 **40**		153 153 153	
White		0 0 0	

POSTER COMP Donald Brun, designer. The first modernists, bored from copying classical styles, embraced the square and circle with a vengeance. Their followers never learned to draw and only knew how to use the T square and compass. The geometric minimalism they touted, also with a vengeance, was founded in their innate insecurity (e.g. Bauhaus, Michael Graves, etc.). Donald Brun, my favorite poster artist, drew realism fantastically well, but could also play with squares. Brun's gouache painted rough, c. 1947, reflects the period's cooling color trend.

13 22 4 **4**		211 178 202	18 45 62 **36**		133 83 49	
37 59 8 **18**		131 75 129	13 31 38 **9**		200 152 120	
70 7 61 **33**		52 111 150	38 35 44 **64**		0 0 0	
0 80 100 **4**		245 0 23	14 29 100 **17**		182 140 3	

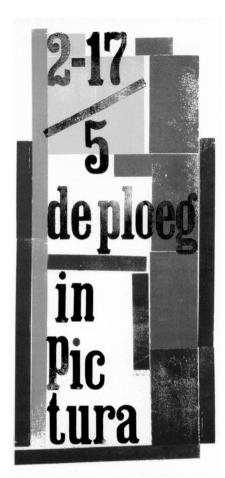

POSTER Hendrik Nicholaas Werkman, designer, 1925. Once every fifty years or so, somebody reinvents grunge and thinks he's clever. This poster for an art exhibition was a cubist experiment with letterpress printing blocks. Werkman also appeared to be making a then-shocking primary color statement with his red, yellow and blue. Today, grunge has become just one more legitimate tool in the designer's official bag of tricks. (I forgot to add it to the list of techniques on page 14.)

83 25 0 **0**	48 132 47
89 0 83 **0**	29 153 75
0 0 0 **18**	209 209 209
40 0 0 **100**	0 0 0
White	255 255 255

54 40 0 **6**	112 116 174
15 0 0 **61**	84 93 96
0 0 0 **24**	194 194 194
0 100 100 **0**	255 0 0
White	255 255 255

100 46 6 **47**	3 46 83
10 95 100 **12**	202 15 0
0 20 91 **0**	255 204 22
0 66 95 **0**	255 87 12

20 33 87 **27**	149 113 24
0 3 9 **0**	255 247 228
40 0 0 **100**	0 0 0

0 100 100 **0**	255 0 0
53 46 0 **20**	97 89 143
100 86 0 **0**	17 24 134
35 47 0 **0**	165 119 184
40 0 0 **77**	35 50 53
White	255 255 255

76 36 100 **0**	61 105 27
17 17 12 **8**	194 183 183
13 6 19 **4**	213 219 189
25 32 35 **4**	182 150 131
19 32 65 **0**	206 160 89
40 42 26 **33**	102 84 95
White	255 255 255

CMYK					RGB		
55	40	100	0		115	114	18
0	0	0	60		102	102	102
0	0	0	14		219	219	219
0	0	59	0		255	255	105
40	0	0	100		0	0	0
White					255	255	255

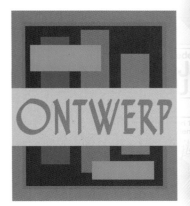

CMYK					RGB		
43	35	0	22		113	109	151
21	26	0	0		199	175	213
22	46	44	23		151	97	83
0	70	90	0		254	77	17
0	70	67	36		161	50	35
25	50	0	69		58	36	57

PAPER MONEY The almighty American buck is king around the world, except to designers. This psychedelic Dutch guilder is another example (see page 37) of the cool design found in most foreign currency, putting our own to shame. Even in the 1920s, American designers like Will Dwiggins were advocating the redesign of American currency with its symmetrical, stodgy, mock-pompous, Victorian-style engraving. The Dutch bill above would certainly bring a smile every time you spent one on local sundries like wooden shoes, tulips, salty licorice or Turkish hashish.

CMYK					RGB		
7	93	55	3		224	21	59
0	31	61	0		253	177	86
22	51	0	0		195	117	183
0	61	32	0		249	101	120

CMYK					RGB		
5	72	8	3		226	70	144
White					255	255	255

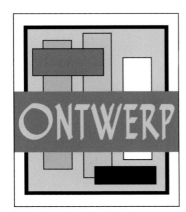

CMYK					RGB		
16	31	4	0		211	166	201
31	0	25	0		176	224	182
42	17	4	0		148	179	206
59	43	7	16		90	95	141
40	0	0	100		0	0	0
White					255	255	255

CMYK					RGB		
16	0	4	10		193	216	213
49	0	5	56		57	91	95
22	0	24	27		145	170	137
31	47	61	0		175	118	77
16	32	59	0		213	162	89

TARTAN ART Cameron Farquharson, designer. As a teenager, Farquharson was once hired to airbrush clan tartan patterns on T-shirts. Now, as a 30-year-old, he creates tartans on computer—with a twist. "I got tired of doing the same old thing, but people still want their colors, and they seem to like this approach." Farquharson says, "Except for the old folks. They say, 'Ay! And what is it you think you're doin', laddie?'"

46 7 15 **0**	139 195 192	70 18 47 **30**	55 104 84
0 70 67 **10**	227 70 49	10 62 67 **20**	182 75 47
83 24 64 **52**	22 59 43	0 28 92 **0**	255 184 19
7 62 63 **38**	145 59 40		

50 10 20 **20**	102 148 143	0 84 100 **0**	255 42 0
50 10 20 **51**	63 91 87	0 80 78 **36**	161 33 22
100 65 0 **32**	9 38 102	100 29 71 **37**	0 64 50
100 65 0 **72**	2 16 42	0 50 59 **0**	252 130 79
76 100 69 **7**	60 0 36	40 12 28 **14**	132 163 140
10 0 6 **4**	221 236 226	10 12 12 **0**	229 216 207

6 20 100 **0**	240 198 2	0 75 87 **0**	254 63 21
10 20 100 **30**	161 137 1	0 46 38 **0**	251 139 122
0 50 100 **0**	255 125 0	0 14 100 **0**	255 219 0
100 50 10 **0**	9 79 148	80 13 73 **28**	37 104 59
0 75 75 **10**	228 59 36	80 29 26 **19**	44 101 118
70 28 100 **50**	38 62 14	100 29 73 **54**	0 46 35
100 65 10 **71**	2 16 40	2 6 17 **0**	250 238 205
50 60 30 **0**	128 83 120		

0 64 67 3		244 90 55
15 70 90 30		152 51 13
75 0 70 24		49 130 71
100 0 70 60		0 57 39
100 50 10 0		9 79 148
100 69 48 17		5 39 70
47 50 23 8		125 96 128

6 20 100 0		240 198 2
10 20 100 30		161 137 1
0 100 86 16		212 0 16
0 69 62 0		251 81 64
0 100 79 47		133 0 14
40 0 0 100		0 0 0

90 70 20 40		20 30 71
90 70 11 0		36 51 134
70 0 100 38		48 106 24
70 28 100 50		38 62 14
0 15 100 0		255 217 0
0 26 100 26		189 140 0
4 4 0 22		191 188 193
40 0 0 100		255 255 255

0 65 65 0		252 90 60
20 15 25 15		173 170 146
6 65 65 30		166 62 42
20 27 33 42		118 100 84
65 65 0 22		73 54 123
65 72 87 22		70 39 161

TARTAN ART Cameron Farquharson, designer. The artist, a native of Dingwall in the north of Scotland, takes a slightly more normal approach to his design for the "Leslie" clan, which appeals to me for some reason! (*Note:* All the color combinations—though not the patterns—in the small layouts on these pages were derived from authentic Scottish tartans.)

7 0 0 16		199 208 211
80 20 73 11		46 118 69
100 41 75 43		1 56 44
0 67 70 0		252 85 51

29 78 66 18		147 41 44
83 68 3 87		8 8 19
45 24 3 17		117 134 165
63 48 3 33		65 69 113

LATIN AMERICAN

There is much about Latin American design that seems crass and unsophisticated. This aspect may start with the yearning to emulate American advertising and television programming. But when artists and artisans south of our border are left to do their own thing, as with traditional crafts, there is a warmth, complexity and sophistication that ranks their work among the world's finest. ■ Mexicans adore bright, eye-popping colors like sky blue, acid yellow and the so-called "Rosa-Mexicana" (hot pink). These colors are seen not only in fabric design, but increasingly on building exteriors—due to the influence of Mexican architects like Luis Barragán and Ricardo Legorreta. Mexican women like to adorn their own exteriors with vivid, masklike makeup. Much has been written about Mexicans wearing a "mask" on their emotions, possibly due to the necessity of keeping anger in check within a colonized country. ■ With the enormous disparity between the ruling elites and the indigenous peoples of many Latin American countries, the folk arts flourish as a celebration of identity. Much of their art involves ancient religious symbology that's been grafted onto that of the Catholic religion imposed upon these countries by their "conquerors." ■ Ironically, certain regional "dress codes," such as those of Guatemala, were reinforced by the Spaniards who dictated that each group wear only a certain pattern so they might be more easily identified and counted. Certain patterns and colors that we now associate with Latin America were hand-me-downs from Spain. ■ Peru, with its awesome remnants of the Incan empire is a fascinating place to visit. The colors of Peru range from the modern, like the Web site designs shown in this section, to the traditional that seem to have an almost plaintive feeling. ■ With its vast size and economy, Brazil is a major player in Latin America. It, too, is a land of haves and have-nots. To me, Brazilian colors seem to be in transition from the traditional to the industrial as their graphic design integrates itself into the modern world. Whether this is a good or bad thing, it is the trend in most third world countries around the globe.

COLOR

17 25 100 **0**		212 176 7
17 58 100 **24**		161 75 1
10 12 41 **0**		229 215 140
40 0 0 **100**		0 0 0
White		255 255 255

0 41 0 **0**		249 152 202
65 15 52 **0**		90 158 114
0 94 100 **21**		201 15 0
0 20 100 **0**		255 204 0
40 46 45 **0**		150 115 106
40 0 0 **100**		0 0 0

GAME CARDS The Loteria, of which these cards are a part, is a popular game in Mexico, similar to bingo or lotto. The style of the comic drawings indicates that they were created in the 1920s, although these same designs are still in use, even today. A fairly limited palette of warm colors links the different game cards, and even the set of swatches below look pleasing.

37 3 49 **0**		161 209 127
62 4 0 **0**		98 188 216
0 7 56 **0**		255 237 108
0 35 53 **0**		253 167 99

0 71 94 **0**		254 74 12
0 13 90 **0**		255 222 25
48 7 94 **0**		133 185 37
40 0 0 **100**		0 0 0

61 41 0 **0**		102 117 181
17 17 0 **0**		211 199 225
29 0 36 **0**		181 225 158
59 77 0 **0**		109 48 148
40 0 0 **100**		0 0 0

4 17 20 **0**		243 209 186
40 49 80 **0**		153 107 45
40 49 80 **52**		73 51 22
49 49 0 **0**		131 108 177
40 0 0 **100**		0 0 0

9 9 0 64		83 82 86		
45 0 86 0		140 203 54		
53 29 0 0		121 146 196		
40 0 0 100		0 0 0		

70 0 17 0		78 186 185	
100 65 0 0		13 56 150	
45 0 86 0		140 203 54	
40 0 0 100		0 0 0	
White		255 255 255	

MAGAZINE COVER The six colors used to produce this 1940s cover of *Mexican Life* magazine appear to be similar to those of the Loteria cards, opposite, only turned up a notch. Pink is a staple of the Mexican color diet, yet somehow it never comes out looking the same as when Asians use pink. Note that the color set that looks harmoniously balanced above looks crass and forlorn in swatch form below. Again, context is everything.

57 5 56 20		89 147 90		84 52 0 7		46 82 154
5 56 13 0		236 112 158		0 82 100 7		237 43 0
0 4 21 0		255 245 197		40 0 0 100		0 0 0
0 9 100 0		255 232 0				

22 45 60 0		198 127 80	
19 58 26 7		189 93 122	
36 100 31 7		150 0 81	
44 47 0 0		143 114 181	
58 0 100 0		107 186 32	
64 68 0 0		97 63 155	
40 0 0 100		0 0 0	
White		255 255 255	

39 24 52 0		156 163 108	
0 19 53 0		254 207 109	
60 33 82 20		82 100 42	
27 26 0 69		57 53 65	
0 3 28 0		255 247 181	
12 12 0 14		192 185 201	
39 85 53 7		144 31 64	
21 11 76 0		201 206 63	

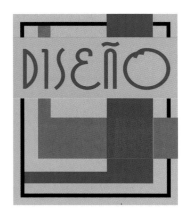

WEB PAGE DESIGN Bishö.com, designer. The name "Bishö" comes from the word *bicho* (bug). "We just 'stylized' the word," a spokesperson explains. "We define our current style as 'neogothic.' We wanted a logo that was well-balanced: fresh, dynamic, young, but also seriously professional to reflect our experience (twenty years!)." The conch shell centerpiece forms a dynamic contrast against the dark, neogothic background of the firm's Web site.

70 0 100 0		77 172 38
100 42 0 0		9 93 167
87 93 23 0		44 14 101
0 11 100 0		255 227 0
White		255 255 255

14 12 12 17		181 176 170
85 75 16 13		42 38 108
0 23 100 8		235 181 0
13 100 100 13		193 0 0
25 0 0 63		70 85 88
40 0 0 100		0 0 0

27 23 76 10		168 156 54	100 83 4 0		16 28 131
54 0 22 0		118 201 181	51 3 90 40		75 81 22
12 54 0 0		218 114 182	55 35 75 55		52 57 28
33 88 30 30		118 21 69	40 0 0 100		0 0 0

74 8 0 0		68 170 206
78 74 0 0		65 48 147
28 85 100 6		173 32 1
0 35 100 7		237 156 0
White		255 255 255

45 6 100 0		140 189 24
36 86 100 11		145 28 1
12 75 31 0		218 63 109
38 75 23 3		152 55 115
0 22 79 0		254 199 48

80 0 70 **10**		46 149 85
100 0 50 **40**		0 89 76
White		255 255 255

40 35 90 **0**		153 136 50
70 90 100 **30**		54 12 1
25 0 100 **35**		124 146 9
White		255 255 255

11 60 90 **0**		226 97 20
70 80 100 **0**		77 34 8
0 27 100 **10**		230 168 0
White		255 255 255

100 0 35 **40**		0 91 89
0 0 0 **40**		153 153 153
White		255 255 255

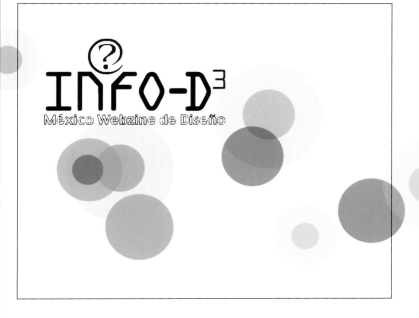

WEB PAGE DESIGN Another Web site design by the Bishö team. This time it's a Flash animation with variously colored circles dynamically blossoming and fading before our eyes. This is an example of how CMYK inks fail to match the brilliant luminosity of RGB colors as they appear on the Web. Slightly gaudy but very eye-catching; try these colors out for yourself using the RGB formulas below.

53 0 7 0		5 255 254
35 82 0 0		224 35 225
48 0 63 0		129 255 129
0 4 93 0		255 255 32

14 0 5 0		235 255 254
25 60 0 0		255 107 255
7 0 9 0		224 255 224
0 3 19 0		255 255 191

BLANKET DESIGN This Mexican blanket from the 1920s came from a roadside stand in Arizona. Above is only a small section of this highly detailed weaving containing at least one hundred colors (I had to choose just eight, below). The complexity of this design and the intensity of its colors remind me that even with folk art, the folk artists in older days seemed to have a lot more patience than most of us do now.

CMYK	RGB		CMYK	RGB
21 67 100 **13**	175 66 2		41 7 66 **11**	134 173 180
0 83 47 **0**	249 46 79		76 56 12 **45**	37 44 80
25 89 75 **33**	127 18 24		38 65 8 **12**	138 69 133
9 20 16 **3**	223 191 184		0 7 33 **0**	254 237 165

CMYK	RGB		CMYK	RGB
5 16 43 **10**	217 189 120		3 16 100 **0**	247 211 1
50 20 10 **10**	115 149 170		0 90 72 **12**	221 24 34
90 58 65 **0**	30 66 68		77 100 0 **0**	70 0 125
0 73 100 **49**	130 35 0		40 0 0 **100**	0 0 0
0 30 100 **35**	166 116 0		White	255 255 255
11 4 10 **0**	221 228 215			

CMYK	RGB		CMYK	RGB
71 0 100 **0**	74 171 39		73 32 0 **0**	73 127 185
73 100 0 **0**	79 0 125		72 80 0 **24**	60 29 108
40 0 0 **100**	0 0 0		0 33 20 **3**	243 167 165
White	255 255 255		5 0 4 **0**	242 250 242
			40 0 0 **100**	0 0 0

0 65 100 **11**		227 80 0	
39 25 35 **5**		148 153 132	
40 0 0 **100**		0 0 0	
White		255 255 255	

39 25 35 **5**		148 153 132	
80 35 100 **29**		36 74 20	
0 18 100 **0**		255 209 0	
21 91 49 **0**		197 23 70	
39 25 35 **33**		105 108 94	
White		255 255 255	

11 63 100 **0**		227 89 1	
0 31 49 **0**		253 177 110	
61 53 0 **0**		103 94 170	
30 11 72 **0**		179 197 74	
39 100 100 **0**		156 0 0	
100 50 0 **56**		3 35 71	

30 32 54 **5**		169 144 94	
0 20 100 **0**		255 204 0	
0 74 90 **0**		254 67 16	
37 73 100 **0**		161 58 4	
White		255 255 255	

WEDDING DRESS This fabulous embroidery comes from the Chiapas region of Mexico. Here we find yet another indigenous people, the Chiapas Indians, who have the audacity to lay claim to their traditional homelands, depriving other, more "civilized" Mexicans from profiting from these lands. As writer Carlos Fuentes explains, "There are 10 million Indians in Mexico who speak 42 languages and have alternative cultures and values. They are not barbarians or uncivilized people. They are simply people with another culture."

32 91 9 **0**		170 23 124	
87 32 0 **0**		39 117 179	
13 100 100 **6**		209 0 0	
0 66 85 **0**		254 88 26	

78 15 93 **21**		45 110 38	
93 70 4 **5**		29 48 135	
White		255 255 255	

Ritual del Día

Lunes Martes Miercoles Jueves Viernes Sábado Doming

WEB PAGE DESIGN Karen Wicht, designer for Magia Comunicaciones. In this design for an online horoscope, Wicht used a duotone background effect in tones of blue, which she felt was a good way to add texture to the site without causing the distraction of a full-color image. As in the above design, interesting and unanticipated shades often result from the layering of transparent colors and images.

100 68 17 **38**		6 31 78
4 33 58 **0**		243 169 90
52 15 7 **0**		123 174 197
90 45 9 **9**		30 84 141

68 40 13 **19**		69 92 129
65 24 10 **7**		85 136 166
White		255 255 255

6 20 100 **0**		240 198 2
6 66 66 **0**		237 83 58
5 10 20 **0**		241 226 192
100 38 70 **0**		1 89 75

0 86 79 **0**		252 38 31
30 84 54 **30**		122 26 47
100 0 100 **29**		0 97 39
3 70 13 **16**		200 66 121

11 17 100 **20**		182 161 2
52 75 24 **27**		90 38 85
22 90 100 **20**		159 19 0
14 9 0 **9**		199 200 215
17 67 82 **13**		184 68 28
61 23 15 **0**		101 150 172

24 17 100 **20**		155 151 9
41 51 23 **23**		115 82 107
5 12 18 **5**		228 209 185
40 0 0 **100**		0 0 0

100 38 15 **23**	4 75 115
26 34 80 **15**	160 126 41
0 64 37 **15**	212 80 93
7 7 26 **0**	237 230 180
60 80 64 **15**	88 33 48
27 35 30 **4**	178 159 162
24 100 100 **0**	194 0 0

70 22 100 **44**	43 77 17
90 60 0 **10**	32 62 141
0 44 60 **0**	253 144 80
21 100 54 **31**	136 0 40
0 11 83 **0**	255 227 42
26 19 100 **0**	189 182 12

WEB PAGE DESIGN Karen Wicht, designer for Magia Comunicaciones. Here is a Web page created for a Peruvian bank. The blue used is the company's corporate color. Wicht chose the green because "it worked harmonically with the blue and gives the Web site a futuristic and technological look." The same green used on the Pagonet logo/button "allows the eye to be drawn immediately to the navigation."

20 3 76 **0**	204 225 66
100 82 9 **5**	14 28 119
71 26 100 **25**	56 95 22
47 15 74 **0**	135 172 72

11 5 20 **0**	227 232 195
40 0 0 **100**	0 0 0

39 84 87 **35**	101 23 14
22 15 33 **0**	199 198 154
80 46 0 **40**	34 59 102
0 30 100 **20**	204 143 0
0 80 80 **20**	202 41 24

49 28 28 **17**	109 123 122
40 60 100 **0**	153 83 9
60 80 100 **30**	72 26 3
0 70 65 **30**	177 55 41
11 12 26 **0**	226 215 175

Nebaj

Quiché

43 11 4 **0**		146 190 211
0 19 100 **0**		255 207 0
0 81 100 **0**		255 48 0
18 100 0 **8**		184 1 117
White		255 255 255

50 0 60 **5**		121 190 102
84 0 52 **20**		34 132 99
60 0 0 **15**		87 168 188
100 74 0 **0**		15 42 143
0 0 0 **73**		69 69 69
White		255 255 255

COSTUME ILLUSTRATION Undoubtedly, the most colorfully costumed people in the Americas are the Highland Maya of Guatemala. Here a high percentage of the indigenous people still proudly wear their traditional dress called "*traje*." Nebaj is a town high in the Altos Cuchumatanes mountains. The people of Nebaj speak Ixil, and are one of Guatemala's smaller ethnolinguistic groups.

30 19 57 **11**		159 161 90
30 73 86 **24**		136 46 20
27 82 69 **16**		155 35 40
7 38 100 **0**		237 153 1

80 16 24 **15**		45 125 134
3 3 25 **0**		247 244 187
0 71 100 **0**		255 74 0
40 0 0 **100**		0 0 0

78 60 10 **0**		63 73 145
0 0 90 **0**		255 255 24
22 30 40 **0**		198 163 128
0 100 66 **0**		250 0 43
40 0 0 **100**		0 0 0
White		255 255 255

10 10 10 **10**		204 233 92
60 44 0 **30**		74 79 126
40 70 80 **10**		138 57 33
0 6 77 **3**		247 232 56
0 77 77 **0**		252 60 36
40 0 0 **100**		0 0 0

48 78 10 **0**	134 48 134
7 15 23 6	222 199 169
0 80 100 0	255 48 0
72 9 0 0	73 168 191
3 69 0 0	237 81 166
100 0 100 **58**	255 255 255

35 77 100 **10**	148 45 2
35 50 7 **4**	163 111 167
73 100 0 **42**	46 0 72
0 71 29 0	248 76 117
58 0 65 **9**	98 174 89
White	255 255 255

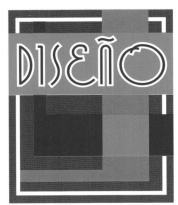

52 69 0 **0**	124 65 156
100 50 0 **17**	8 67 134
16 26 50 8	196 163 102
15 4 9 5	206 219 209
40 0 0 **100**	0 0 0

0 100 100 **18**	209 0 0
100 79 0 **0**	15 35 140
82 0 55 **0**	47 166 119
52 69 0 **0**	124 65 156
White	255 255 255

Santa María Chiquimula

Totonicapán

COSTUME ILLUSTRATION The Chiquimula are the gypsies of Guatemala. They lost their land in the province of Totonicapán about 150 years ago and now wander around Guatemala. They are said to favor red and black clothing and wear lots of ribbons in their hair. They have never given up their traditional dress, even though it readily identifies them to other ethnic groups who discriminate against them.

23 73 29 **4**	185 62 108
0 3 90 **0**	255 247 26
75 22 0 **7**	63 134 179
25 17 50 **4**	183 182 111

3 36 40 **0**	244 162 125
24 72 84 **32**	131 43 20
39 70 5 **13**	135 59 131
7 48 100 **5**	242 130 1

50 15 100 **40**		76 100 14		
26 66 90 **11**		168 69 19		
100 66 0 **9**		12 50 136		
0 55 100 **0**		255 115 0		
40 0 0 **100**		0 0 0		
White		255 255 255		

0 34 100 **10**		230 152 0
12 5 100 **0**		224 228 6
26 94 82 **5**		178 16 24
40 0 0 **100**		0 0 0
White		255 255 255

PACKAGING In the absence of Ovaltine or Bosco, Guatemalen children can fortify themselves with Incaparina, which is "good for all the family." The packaging design is bold and eye-catching, simple and appealing. So much sales power can be accomplished with so little design!

0 6 33 0		255 240 166	White	255 255 255
0 100 86 5		253 0 19		
0 7 87 0		255 237 33		
40 0 0 100		0 0 0		

100 69 0 **45**		7 28 81
73 66 0 **0**		76 65 155
0 31 100 **0**		255 176 0
20 25 10 **0**		202 177 194
White		255 255 255

29 40 0 **0**		179 138 194
73 100 0 **0**		79 0 125
0 40 100 **0**		255 153 0
30 22 13 **22**		139 138 146
40 0 0 **100**		0 0 0
White		255 255 255

6 12 34 **0**		239 219 157	
18 42 72 **0**		208 137 59	
35 100 80 **0**		165 0 25	
65 0 15 **0**		90 191 191	
100 58 56 **0**		4 62 81	

36 8 10 **5**		155 192 195	
40 25 80 **10**		138 141 49	
10 20 100 **0**		230 195 3	
0 100 40 **40**		148 0 46	
10 10 35 **0**		229 221 156	
10 10 10 **10**		58 128 148	

77 0 35 **30**		42 123 107	
28 0 30 **63**		68 83 63	
29 0 36 **11**		161 199 140	
40 0 0 **100**		0 0 0	

0 35 100 **0**		255 166 0	
60 80 0 **0**		106 41 144	
80 0 100 **0**		51 160 44	
0 100 100 **0**		255 0 0	
23 0 74 **0**		196 229 72	
White		255 255 255	

PAINTING Lorenzo Gonzalez Chavajay, artist. This wonderful example of contemporary folk art is a morality play about the evils of drinking. While the salvation of the church beckons in the background, drunken boys brawl to the dismay of their parents. The tradition of art as a narrative medium and for recording events is as old as mankind itself. It survives in works such as the above. Some of the most interesting colors are found in the figures' clothing.

13 27 45 **0**		221 177 120		86 31 42 **7**		37 106 110	
60 7 100 **0**		102 171 31		85 28 100 **30**		252 141 79	
0 10 29 **0**		254 230 172		17 82 100 **9**		193 39 0	
10 10 10 **10**		209 104 36		38 58 80 **54**		72 41 19	

12 7 100 **0**		224 223 6
0 30 100 **0**		255 179 0
26 7 100 **20**		151 167 11
13 85 84 **6**		207 35 23
100 80 32 **0**		10 31 98

100 80 0 **0**		15 33 139
13 100 100 **0**		222 0 0
0 0 30 **16**		214 214 150
0 0 100 **65**		89 89 0
24 48 22 **0**		192 122 147
40 0 0 **100**		0 0 0
White		255 255 255

ALBUM COVER Although the Rio Carnival Orchestra comes from Brazil, the record, c. 1965, comes from Pennsylvania. The design is a good one, however, and reasonably authentic, too. The colors seem to fit right in with those on the rest of this spread. I've included three sample colors taken from the red-cast Brazilian stock photos, even though I haven't included them in the layouts below.

74 68 11 **0**		73 60 138
10 0 100 **0**		230 243 4
0 63 35 **0**		249 96 113
28 40 65 **20**		147 108 59

24 21 25 **0**		193 182 165
15 49 53 **0**		215 123 91
30 68 71 **40**		107 43 30
40 0 0 **100**		0 0 0

66 0 100 **7**		81 164 34
12 0 100 **5**		212 228 6
78 86 0 **0**		66 28 137
10 6 0 **0**		230 231 242

100 72 0 **0**		14 45 145
69 0 8 **0**		80 188 202
69 0 8 **35**		52 122 131
0 0 82 **0**		255 255 47
0 40 82 **0**		254 153 37

0 66 100 **0**		255 87 0
100 80 0 **0**		15 33 139
40 0 0 **100**		0 0 0
White		255 255 255

17 49 20 **29**		149 87 108
27 80 47 **46**		99 25 43
17 53 76 **0**		211 112 47
7 33 67 **0**		236 166 71
6 18 15 **10**		212 183 175

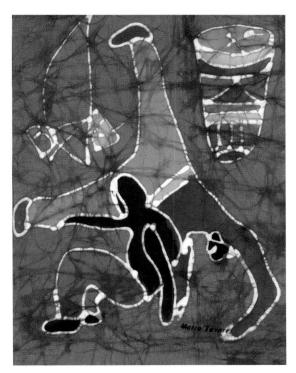

BATIK DESIGN No, it's not breakdancing, but Capoeira, which developed in Brazil during the time of slavery as a mixture of fight, play, and dance. Under the watchful eye of the slave owner, Capoeira appeared as a harmless dance. Practiced on a day off, it was a moment to forget the horrors of slavery. Today, as in the past, Capoeira keeps the body fit, and the mind sharp and strengthens the community.

52 48 43 **20**		98 84 86
36 80 63 **36**		104 28 36
0 75 100 **0**		255 65 0
6 100 82 **0**		238 0 23

4 38 100 **0**		245 155 1
69 27 53 **18**		66 108 86
93 58 3 **0**		29 70 153
40 0 0 **100**		0 0 0

81 42 0 **0**		54 104 173
12 11 0 **13**		195 189 205
39 28 0 **50**		78 79 101
54 30 0 **0**		119 144 195
23 0 0 **0**		196 233 242
54 3 0 **0**		118 200 222
White		255 255 255

46 7 100 **0**		138 186 24
50 25 75 **0**		128 149 66
80 30 100 **0**		51 112 31
37 84 66 **0**		160 36 51
40 0 0 **100**		0 0 0
White		255 255 255

FLOUR PACKAGE A hysterical and novel dichotomy is explored in this package design. Namely, here is a *black* chef serving up "blanca flor" or *White Flower* brand flour. Get it? Black and white; blanco y negro! The chef is portrayed in a comic manner long ago deemed inappropriate in most countries. But with little to no black or even Indian stock in the whole country, Argentinians, who like to think of themselves as Europeans, may lack experience and sensitivity in such matters.

60 14 0 0		103 170 207
17 100 63 0		209 0 47
40 0 0 100		0 0 0
White		255 255 255

0 20 40 0		253 204 138	0 22 0 0		252 200 227
71 45 0 0		79 104 174	0 100 49 0		247 0 65
46 26 0 0		139 157 202	58 72 0 0		111 57 152
0 41 83 0		254 150 35	58 72 0 47		59 30 80
27 75 100 0		186 56 2	6 29 0 24		180 135 164
40 0 0 100		255 255 255	40 0 0 100		0 0 0

0 9 79 0		255 232 52	0 6 100 6		240 226 0
24 24 7 9		175 155 178	42 6 100 6		139 181 21
82 89 0 15		49 18 114	71 0 100 16		62 143 33
24 0 23 29		138 164 134	40 0 0 100		0 0 0
White		255 255 255	White		255 255 255

8 12 16 **0**		234 218 198	
14 23 25 **0**		217 186 166	
14 31 25 **35**		141 109 103	
14 11 50 **24**		166 162 91	
14 31 25 **57**		93 72 68	
40 0 0 **0**		0 0 0	
White			

0 23 51 **0**		253 196 111	
5 44 0 **0**		236 142 197	
15 100 86 **0**		216 0 18	
62 20 100 **12**		85 127 24	

0 16 100 **14**		219 184 0	
4 4 0 **5**		232 229 235	
88 44 0 **20**		31 77 136	
21 16 0 **21**		158 156 177	

0 63 100 **0**		255 94 0	
100 5 39 **0**		1 143 139	
23 29 57 **0**		195 164 95	
0 67 100 **39**		156 52 0	
40 0 0 **100**		0 0 0	
White		255 255 255	

PACKAGE DESIGN You learn something new every day! When I selected this yerba mate herbal tea for the packaging, little did I suspect I'd become one of its proponents. Yerba mate tea, a South American favorite for centuries, has been called the "Drink of the Gods" because it contains "practically all of the vitamins necessary to sustain life." Over 300,000 tons of the stuff are produced yearly, so that says something!

5 6 66 **0**		242 235 86	
8 95 95 **0**		234 17 9	
64 5 55 **4**		89 169 110	
64 23 27 **26**		70 108 112	

45 8 0 **0**		141 196 221	
62 39 22 **38**		62 73 91	

AFRICAN

I'd always assumed that the partially decomposed coliseum in Rome had merely fallen victim to the ravages of time. Then I learned that centuries after the fall of the Roman Empire, the outmoded coliseum had been considered a "legitimate quarry for building materials" and thus was conveniently deconstructed. ■ Today I'm wondering what Africa would have been like if it had not been considered a legitimate quarry for human beings and easy prey to any European country with a naval fleet and an excess of greed. ■ Of course, infighting among nations and tribes has always occurred on every continent, even when left unmolested by outsiders. But having visited various parts of Africa, I'm left to wonder if the state of many African nations would be as chaotic, with impoverishment so acute and health so threatened, had it not been for centuries of imperialist intervention. ■ If Africa is the birthplace of mankind, as many contend, then it is also the birthplace of design. The ancient Egyptians had something to say about that, even if they said it in rebus. I used to consider Egypt part of the Middle East until it was pointed out

to me (duh!) that Egypt is on the African continent. Isn't it suspicious that most of the ancient Egyptian figural sculptures, including the Sphinx, that bear African features had the noses knocked off? Many believe it was done purposely to obscure the Egyptian–African connection. Of course, red-skinned Atlanteans and aliens were also part of the ancient Egyptian cultural mix. ■ I found Africa to be filled with a multitude of colors that I had not expected. Whether consciously or unconsciously, it seems the human body becomes the initial reference for color selection. For instance, the lighter-skinned Ethiopians favor lighter color combinations, while the Ghanians prefer the rich golden yellows, deep oranges, royal blues and greens of the traditional kente cloth that goes so well with their darker colored skin. ■ Africa is a continent in tumult with numerous ongoing wars, much civil unrest, a staggering burden of debt to the World Bank and a frightening health crisis. On the other hand, there is so much beauty in Africa, so many determined and loving people. ■ The Akan of Ghana have a phrase: *"Obakofo mmu oman,"* which means "One person does not rule a nation." The Akan believe democratic rule requires consultation, open discussion, consensus building and coalition formation. They include the queen mother as a co-ruler along with a council of elders in their version of participatory democracy. If only America and other nations embraced the Akan approach.

COLOR

16 27 56 **0**		213 174 97
24 38 13 **0**		192 145 173
24 0 33 **26**		144 171 123
58 82 100 **0**		107 34 5
White		255 255 255

0 75 75 **0**		252 65 40
0 75 75 **30**		177 46 28
40 0 0 **100**		0 0 0
White		255 255 255

PAINTING The scene depicts Ethiopian King Ezana, the most famous of the Aksumite kings, going into battle. His most significant contribution to Ethiopian history was his official adoption of Christianity around 333 A.P. Though the work above is contemporary, it was painted on true parchment, that is, animal skin that has been scraped flat and dried. This was how some of the first "paper" was made.

4 43 58 **0**		243 143 84
76 13 76 **44**		35 82 42
0 6 90 **0**		255 240 25
74 15 0 **0**		69 157 200

17 6 35 **3**		205 217 153
19 13 87 **8**		191 187 35
4 0 7 **0**		245 251 235
0 78 52 **0**		250 58 74

0 100 60 **30**		175 0 36
70 0 3 0 **10**		70 166 147
0 0 0 **70**		77 77 77
0 0 25 **10**		230 230 172

15 70 90 **30**		152 51 13
0 20 100 **0**		255 204 0
10 40 100 **30**		181 103 1
70 0 100 **40**		46 103 43
40 0 0 **100**		0 0 0
White		255 255 255

0 5 45 **10**		230 218 123		
100 0 55 40		0 88 72		

0 10 90 **5**		230 207 22		
0 30 80 0		254 179 43		
70 0 30 10		70 166 147		
40 0 0 100		0 0 0		
White		255 255 255		

EMBROIDERED FABRIC The imperial lion is featured in this cloth emblazoned with the Ethiopian tricolors: green, gold and red. A left-facing lion signifies a period when Ethiopia is in a condition of adversity and distress, and it honors those who fought for Ethiopia's reconstruction and resurrection. When I scanned this cloth, I couldn't tell which side was up or down, but I think Ethiopia is doing okay at the moment.

53 86 3 **18**		101 26 111	67 29 49 **45**	47 72 60
75 20 52 5		62 133 105	17 39 89 8	195 133 25
4 16 88 0		245 210 31	15 87 67 5	203 31 45
4 89 84 0		243 29 23	40 0 0 100	0 0 0

10 85 35 **0**		224 40 95	
100 0 70 40		0 95 113	
60 0 70 0		102 188 90	
10 0 25 10		230 245 188	
0 65 90 0		254 90 18	
35 30 60 25		124 114 67	

5 0 25 **3**		234 242 183	
100 30 90 0		0 97 53	
0 0 25 80		51 51 38	
0 0 10 50		127 127 115	

20 100 70 **30**		141 0 27
20 40 60 **0**		293 140 83
40 0 0 **100**		0 0 0
White		255 255 255

30 100 60 **30**		124 0 35
60 35 0 **0**		104 130 87
0 20 100 **0**		255 204 0
100 0 100 **60**		0 54 22
40 0 0 **100**		0 0 0
White		255 255 255

BEER LABEL The Germans think they have a patent on beer, but this African beer was not too bad. Harar Brewery is located on the outskirts of the historic town of Harar in eastern Ethiopia. The brewery is well known for the popular taste of its beer. The brewery originally set up shop with equipment from Czechoslovakia, hops from Germany and a beer label from the outer reaches of the Pantone spectrum.

18 15 82 **7**		194 185 45
3 45 20 **0**		242 140 157
0 67 100 **0**		255 84 0
0 87 81 **0**		253 35 27

| 40 0 0 **100** | | 0 0 0 |
| White | | 255 255 255 |

60 0 80 **10**		92 168 64
40 50 100 **0**		153 103 11
0 100 40 **20**		197 1 61
25 100 0 **0**		185 1 126
40 0 0 **100**		0 0 0

0 57 100 **0**		255 110 0
100 22 100 **15**		0 90 37
15 7 100 **0**		217 220 8
0 14 66 **9**		232 199 74
40 0 0 **100**		0 0 0
White		255 255 255

CMYK		RGB
40 25 30 0		153 161 149
10 100 50 45		123 0 35
0 45 100 5		242 133 0
85 0 85 35		26 102 46
40 0 0 100		0 0 0

CMYK		RGB
10 80 40 10		202 46 82
70 0 40 10		70 164 130
75 80 0 10		66 34 128
0 10 25 3		246 223 176

BOOK COVER Jealousy is the subject of this book, which also involves exorcism. I like the effect of warm pink to highlight the blue–gray of the hands and face. It's one of those color combinations I never would have thought of had I not been scouring the streets of Addis Ababa looking for something interesting to put in my Ethiopian section.

CMYK		RGB
30 80 100 20		143 35 1
0 50 100 20		204 102 0
15 0 0 10		196 217 222
40 0 0 100		0 0 0
White		255 255 255

CMYK		RGB
0 5 50 0		255 242 124
0 100 100 0		255 0 0
72 0 100 0		71 169 40
0 17 100 0		255 214 0
9 29 100 7		216 161 2
40 0 0 100		0 0 0
White		255 255 255

CMYK		RGB
60 36 6 4		100 122 170
0 13 100 0		255 222 0
0 77 77 0		252 60 36
33 25 32 7		159 154 135

CMYK		RGB
11 20 24 0		225 196 172
0 10 20 0		254 230 194
40 0 0 100		0 0 0
White		255 255 255

CANDY WRAPPER In viewing this candy wrapper, a certain maturity level is demanded of the American reader. Remember, initials don't always carry the same significance in other countries, and they frequently must be altered to avoid confusion or even legal conflicts. For example, the popular cartoon character Elmo Aardvark is known as *Flip Le Fourmilier* in France, and as *Guglielmo* in Italy. In any event, it's not the name but the colors of this candy wrapper that concern us. They are, coincidentally or not, the basic red, yellow and green comprising the African national spectrum. All that considered, this design gives a whole new meaning to "melts in your mouth, not in your hand."

0 85 95 0	254 40 10
71 11 100 7	69 141 32
0 35 100 0	255 166 0
25 64 62 53	89 39 31

0 19 21 0	253 208 182
0 39 37 0	251 157 130
41 9 17 6	141 184 177
6 11 52 0	239 222 115
16 44 37 27	154 98 90

8 31 60 0	234 171 87
21 90 100 0	201 24 0
82 18 34 12	43 123 123
8 14 72 0	235 212 68
13 72 100 26	164 50 0
40 0 0 100	0 0 0
White	255 255 255

20 57 21 13	173 88 121
43 80 50 19	118 35 61
14 45 82 0	218 131 39
0 82 100 33	171 31 0
31 12 53 0	176 196 113
72 33 100 12	63 100 23

47 38 7 11	121 116 157
78 86 64 0	60 25 53
6 12 67 0	240 218 80
14 34 100 0	219 157 4
0 82 100 33	171 31 0
34 5 7 0	168 211 215

28 100 53 **15**		154 0 50	
48 30 7 **5**		127 140 175	
14 50 100 0		219 119 2	
40 0 0 **100**		0 0 0	
White		255 255 255	

37 31 7 **11**		143 135 167	
48 11 56 **5**		127 172 103	
13 61 41 0		218 95 103	
9 13 38 0		231 214 147	
9 35 41 0		230 161 123	
14 60 87 0		218 96 26	
5 5 0 5		229 225 233	

7 26 91 0		237 183 23	
14 66 91 0		218 82 18	
80 24 100 **34**		34 80 22	
19 27 43 0		206 172 124	
50 70 76 6		120 57 41	

28 100 53 **15**		154 0 50	
49 16 100 **21**		103 130 18	
59 50 11 0		104 97 152	
7 19 100 0		237 200 2	
13 13 100 **15**		189 177 4	
3 84 100 **10**		255 38 0	
40 0 0 **100**		0 0 0	
White		255 255 255	

WALL DECORATION From Egypt, via a 1920s print, comes this frieze from the necropolis of Thebes, painted a really long time ago. Many have heard about the curse that felled each of the discoverers of King Tut's tomb. It is also said that all who gaze upon wall paintings (even in reproduction) from the necropolis will die. If you've already looked, too late!

37 13 75 **21**		127 146 54	
11 69 88 0		226 76 22	
7 13 61 0		236 215 93	
64 16 8 **11**		84 144 169	

22 34 66 **7**		184 142 69	
34 5 13 3		163 204 196	
40 0 0 **100**		0 0 0	
White		255 255 255	

40F

LUTTE CONTRE LA VARIOLE ET LA ROUGEOLE

RÉPUBLIQUE DE GUINÉE

POSTAGE STAMP Some have suggested that the World Health Organization's smallpox vaccination campaign, advertised by this stamp design, was the vehicle by which AIDS was purposely spread throughout Africa. I think it's time for such absurd accusations to be put to rest, once and for all. Could a colorful and benign postage stamp as this really harbor such a diabolically genocidal agenda? The rational, scientific explanation: It was the green monkey.

4 21 93 0	245 197 20
6 67 100 0	240 82 0
79 3 79 30	38 112 54
18 45 69 8	192 119 58

11 87 100 3	220 32 0
9 0 11 0	232 246 223
40 0 0 100	0 0 0

3 7 27 0	246 234 179
10 16 45 0	229 206 128
58 16 62 0 0	108 161 95
74 8 2 0	253 67 29
7 12 81 0	237 217 48
0 100 100 67	84 0 0

42 0 88 0	148 206 49
86 30 0 0	42 122 182
100 68 0 0	14 52 148
0 0 0 17	212 212 212
White	255 255 255

77 0 9 0	60 180 196
36 0 90 0	163 213 42
3 0 90 0	247 251 28
33 22 0 26	127 125 11
100 77 0 0	15 36 140

0 11 14 10	229 205 187
0 22 45 10	229 180 112
0 73 100 10	230 63 3
68 90 100 0	82 18 2
63 32 58 0	95 127 93

60 0 25 **8**	95 179 160
33 0 12 0	171 223 210
81 0 31 **73**	13 46 42
19 0 63 0	207 234 97
0 11 52 0	254 227 115

65 0 100 **0**	89 178 36
23 25 51 **0**	195 173 109
36 54 57 **0**	162 100 81
36 54 57 **31**	112 69 56
8 6 10 **0**	234 232 219
40 0 0 **100**	0 0 0

8 55 0 **0**	235 111 1
6 22 29 **0**	238 195 160
4 7 12 **0**	244 234 214
8 55 60 **30**	163 79 52
100 75 0 **11**	13 36 127

10 24 44 **0**	229 187 125
85 6 69 **0**	40 151 93
40 0 0 **100**	0 0 0
White	255 255 255

MUD CLOTH The art of Bogolan mud cloth is practiced by the Bamana people of Mali. The unique and lengthy dyeing procedure remains primarily a women's craft passed on from mother to daughter. The mud used is collected from ponds and left to ferment in a covered pot for about a year. Small pieces of bamboo and flat metal spatulas are used to draw the design onto the cloth using the mud solution. Colors range from yellow ochre to dark brown, and include stark black and white.

25 49 82 **30**	134 81 28
47 65 82 **54**	62 32 17
8 4 18 3	227 230 196
21 41 73 **14**	172 117 50

13 38 58 4		212 144 84
69 4 83 3		77 163 64
White		255 255 255

71 14 65 22		59 118 72
4 0 30 0		245 251 175
40 0 0 100		0 0 0

FABRIC DESIGN An incredible assortment of colorful fabrics roll off Senegal's looms. And while color selection is their strong suit, color registration is not. Still, there is something accidentally attractive about poor printing registration that causes colors to slide way over to where they're not supposed to be. Andy Warhol made it chic and it is still a valid technique in the designers' bag o' tricks (see page 15, tip 19).

0 45 100 0		255 140 0
100 43 0 11		8 81 148
40 0 0 100		0 0 0
White		255 255 255

22 100 71 0		197 0 37
0 57 100 0		255 110 0
100 26 85 0		1 103 61
4 14 94 0		245 215 19
7 12 45 0		236 218 131
36 47 68 0		163 114 66

10 100 54 0		225 0 58
80 64 0 0		59 66 155
40 65 100 5		145 69 7
0 34 100 5		242 159 0
0 6 70 0		255 240 75

64 96 100 **0**		92 11 8	
17 22 100 **0**		212 183 7	
8 10 19 **0**		234 223 194	

24 29 0 **0**		193 167 209	
22 62 100 **0**		199 87 3	
11 14 100 **0**		227 208 4	
52 77 77 **0**		126 47 39	
18 80 83 **0**		208 47 27	

15 45 0 **10**		192 121 174	
0 100 50 **40**		149 0 38	
64 100 77 **15**		79 0 25	
4 4 0 **4**		235 232 238	

22 36 85 **22**		155 115 29	
64 20 5 **12**		83 136 168	
11 6 33 **3**		220 222 159	
10 10 10 **10**		61 67 39	
20 5 20 **3**		197 216 186	
40 0 0 **100**		0 0 0	

FABRIC DESIGN Here is another silkscreen-printed fabric from Senegal. It's two designs in one as the women sport their own color-coordinated garments. I like the way they've twisted the standard red, yellow and blue into something boldly shocking by adding hints of other colors. Senegal is said to be the fashion center of Africa and it's no wonder, since they were colonized by France in the 1880s.

6 0 100 **0**		240 248 3	
100 13 7 **8**		2 127 164	
17 95 90 **6**		199 15 13	
89 17 100 **3**		28 120 39	
40 0 0 **100**		0 0 0	
White		255 255 255	

KENTE CLOTH Kente, the royal cloths made by the Asante people of Ghana, are the best known of all African textiles. Kente is identified by its multicolored patterns, geometric shapes and bold designs, each of which is significant. The most detailed patterns are called "adweneasa," which means "my ideas have come to an end." The pattern above, called "New Ghana," was created at the time of independence in 1957.

16 100 22 **29**		172 1 82
92 0 100 **5**		21 138 48
0 33 100 **0**		255 171 0
33 24 7 **0**		171 170 196

10 100 6 **4**		210 1 115
40 0 0 **100**		0 0 0
White		255 255 255

70 0 45 **0**		78 181 135
0 37 100 **0**		255 161 0
39 100 58 **0**		155 0 53
40 0 0 **100**		0 0 0
White		255 255 255

91 62 0 **0**		34 65 154
30 100 0 **0**		174 1 126
0 48 100 **0**		255 133 0
79 24 100 **4**		52 118 32
14 4 0 **0**		219 232 242
40 0 0 **100**		0 0 0

12 50 76 **0**		223 121 48
82 31 100 **0**		47 109 31
24 81 100 **0**		194 43 1
40 0 0 **100**		0 0 0

46 14 70 **6**		130 165 75
21 67 8 **23**		151 61 117
11 45 4 **18**		181 112 152
5 18 0 **0**		240 206 230
8 16 55 **0**		234 207 106

CMYK					RGB		
10	60	100	0		230	95	10
24	89	100	17		161	210	0
19	28	84	0		207	168	41
5	0	20	0		242	250	202
40	0	0	100		0	0	0

CMYK					RGB		
100	53	0	0		11	76	159
22	100	39	25		145	0	58
21	29	43	0		200	166	1220

CMYK					RGB		
0	31	88	0		255	176	27
70	0	43	0		78	181	139
40	0	0	100		0	0	0

CMYK					RGB		
0	74	47	38		154	42	52
0	72	50	0		250	730	81
12	30	77	0		223	170	53
White					255	255	255

KENTE CLOTH Authentic kente cloths are woven in long strips, about three to four inches wide, and then hand-stitched together edge to edge. While there are a wide variety of colors used, the yellow–orange and burgundy seen above are most typical. The colors of the cloths—even this one made during the 1940s—are so amazingly vibrant and electric they present too formidable a challenge for poor CMYK to meet.

CMYK					RGB		
11	100	48	22		175	0	52
0	40	95	0		255	153	14
96	60	0	0		23	66	155
73	0	100	24		53	128	31

CMYK					RGB		
36	87	68	18		133	24	38
29	20	100	17		150	147	11
40	0	0	100		0	0	0
White					255	255	255

NORTHERN
and EASTERN

We Americans tend to think of Russia as being far away, but Russia is our neighbor. Just pack a lunch and some galoshes and you can basically wade over. With the present leadership vacuum, the Russian Mafia has taken over. Eventually they will become the government just as America's robber barons came to control our nation. All governments are by nature fascist—some control by killing bodies, others by capriciously manipulating interest rates and creating bogus energy crises. ■ Russian color can be divided into three main categories: the red and gold of traditional peasant art, the gray and gray-green remnants of failed communism and the multicolors of modern design influenced by global media. ■ The souls of Eastern Europeans

europe

remained free even as their leaders towed the Communist party line. This is reflected in the colors of countries like Romania, Hungary and the Czech Republic which are sumptuous and optimistic. ■ If there is an advanced race of superbeings, it might be the Scandinavians. They're smart, they like sex—the women too!—and they even design well. On the other hand, they suffer from their own forms of societal repression stemming from the boring sameness that tries to perpetuate itself. Not surprisingly, Scandinavian colors, especially modern selections, seem to combine European and Russian sensibilities. They generally start out bright but end up grayed down. Then there's that cold, cold IKEA blue-and-yellow thing.

an
COLOR

PAINTING Outi Harma, artist. Much of the artist's work is auto-biographical. This painting, *Time to Live Naked*, represents her yearning to be in nature. Her inspirations? "My life, my growth." And her choice of colors? "I don't think about it. It's like improv." Harma says that her work blossomed when she left the "stifling environment" of Finland where "one is not encouraged to be different."

26 27 0 **0**		188 169 209
60 8 11 **0**		103 181 193
42 14 62 **25**		111 134 71
11 6 85 **0**		227 228 42

23 78 59 **43**		110 29 36
8 25 57 **0**		234 185 97
16 47 19 **6**		198 120 146
53 30 49 **65**		42 49 38

78 79 18 **0**		64 39 119
29 8 7 **7**		168 194 199
62 19 64 **0**		98 152 91
0 62 100 **12**		224 85 0
0 0 42 **0**		255 255 148
40 0 0 **100**		0 0 0

50 100 58 **7**		119 0 49
100 40 41 **7**		3 84 105
0 45 100 **25**		204 112 0
0 0 42 **0**		255 255 148
0 81 61 **0**		250 50 59

0 32 32 **0**		252 174 145
12 19 12 **12**		195 174 174
25 89 100 **0**		191 25 0
100 40 41 **15**		3 77 96
56 86 100 **12**		98 24 3
30 45 69 **12**		157 107 57

9 67 11 **0**		225 84 149
0 3 25 **0**		255 247 188
13 3 78 **0**		222 233 59
0 39 100 **0**		255 156 0
40 0 0 **100**		0 0 0

3 3 35 **12**		217 214 143
83 12 38 **20**		36 118 110
3 4 7 **15**		210 206 196
3 3 50 **51**		121 119 61
40 0 0 **100**		0 0 0
White		255 255 255

69 0 14 **0**		80 187 191
0 21 49 **0**		253 201 116
20 0 34 **7**		190 218 153
7 7 7 **0**		236 231 225
0 48 47 **0**		251 134 103
40 0 0 **100**		0 0 0

3 3 35 **51**		121 119 80
41 36 0 **27**		109 101 141
71 40 22 **2**		76 109 142
63 0 14 **0**		95 193 193
0 10 100 **0**		255 230 0
40 0 0 **100**		0 0 0
White		255 255 255

0 4 0 **12**		223 215 219
0 4 0 **25**		190 183 187
35 27 0 **41**		97 96 121
0 4 31 **25**		191 183 129
100 76 0 **30**		11 27 100

PAINTING Outi Harma, artist. Another painting, called *From the Earth,* in which the woman becomes the forest and vice versa. Although the colors in her work often tend toward brilliant "island colors," Harma thinks of the darker palette of her two paintings on these pages as being "more like Finnish colors." Many of the color combinations on these pages seem to bear her out.

3 23 92 **0**		247 193 21
69 30 0 **0**		82 134 189
49 11 26 **7**		121 170 154
55 66 10 **30**		83 49 101

27 14 14 **0**		186 196 194
84 63 0 **0**		51 66 155
49 16 67 **33**		91 114 57
40 0 0 **100**		0 0 0

10 84 0 3		215 43 143
29 38 0 6		169 134 184
10 17 9 3		223 200 203
0 25 36 0		253 192 142
74 56 14 0		72 81 143
40 0 0 100		0 0 0
White		255 255 255

70 0 45 0		78 181 135
62 10 9 0		98 176 194
27 0 5 0		186 229 228
93 10 9 41		13 87 106
0 43 100 0		255 145 0
31 100 100 0		176 0 0
4 0 62 0		245 251 98

EVENT FLYER Raino Annala, designer. Annala is a young graphic artist who has gained a reputation in Finland for his ultra-hip flyers, yet he admits, "I've been fascinated by the Art Nouveau period, and I also love the Russian constructivists." He adds, however, "I try to keep up with things happening today by looking at magazines and cool sites on the Web." Like most young Scandinavians, Annala speaks English better than most Americans.

38 27 28 6		149 149 143	53 0 17 0		121 203 192
66 35 83 50		44 58 25	0 51 95 0		255 125 13
70 3 4 11		211 214 211	54 19 59 15		100 135 84
11 28 59 3		221 172 89	40 64 85 42		89 44 18

100 23 54 0		2 113 106
37 27 54 0		161 157 102
12 6 36 0		224 228 156
21 47 100 0		201 122 5

60 6 51 22		80 140 95
89 24 100 38		18 70 23
0 17 68 0		254 212 75
40 0 0 100		0 0 0

26 17 22 **11**			168 170 156	
16 0 14 **11**			191 213 189	
11 17 53 **0**			226 202 110	
38 49 65 **0**			158 109 70	
50 60 65 **49**			65 41 33	
White			255 255 255	

38 49 50 **0**			158 110 95	
27 0 80 **0**			186 224 160	
59 56 7 **0**			108 88 157	
68 23 7 **0**			85 146 183	
11 10 0 **9**			206 201 215	
38 62 50 **22**			123 64 68	
0 23 100 **0**			255 196 0	

19 100 81 **13**			179 0 21	
0 18 100 **7**			237 194 0	
59 16 29 **18**			87 135 127	
39 9 23 **0**			156 197 176	
12 14 17 **0**			223 209 193	
40 0 0 **100**			0 0 0	

66 13 51 **18**			72 132 96	
12 52 37 **23**			169 90 90	
12 21 17 **0**			222 192 186	
22 22 36 **0**			198 182 142	
White			255 255 255	

EVENT FLYER Raino Annala, designer. The name of this piece is *Ristikko* which means "grid" in Finnish. How does Annala come up with color schemes? "I crank up the curves on photographs and out come these outrageous colors that always work." And that suggestion alone, kiddies, is worth the price of this book.

78 25 38 **24**			45 99 98		26 96 100 **26**		140 10 0
64 19 31 **10**			84 139 133		40 0 0 **100**		0 0 0
0 90 100 **0**			255 26 0		White		255 255 **255**
0 30 100 **0**			255 179 0				

"Dalarna · Leksand"

ILLUSTRATION Florence Sandberg, artist. Here is a beautiful illustration of folk art costuming from the Dalarna region of Sweden. Although the drawing is a simple, cartoon abstraction, the girl's face really looks Swedish. It's fascinating to drive from one country to another and watch how the faces (and the architecture) dramatically change. Near the common border, you notice the faces and the houses begin to show a blending of both nations.

CMYK	RGB
100 86 4 **0**	16 24 129
15 91 100 **5**	206 210 0
3 16 100 **0**	247 211 1
70 12 94 **37**	49 96 28

CMYK	RGB
3 3 3 **0**	247 244 241
40 0 0 **100**	0 0 0

CMYK	RGB
50 100 74 **0**	128 0 32
0 100 100 **0**	255 0 0
39 13 0 **0**	156 190 219
78 46 0 **0**	62 98 171
100 63 0 **23**	10 46 116
White	255 255 255

CMYK	RGB
14 3 31 **0**	219 236 171
21 17 31 **0**	200 194 157
70 36 100 **0**	77 110 255
54 75 100 **0**	117 48 7
20 25 0 **0**	202 178 214
34 36 0 **22**	130 112 153

CMYK	RGB
0 36 100 **0**	255 163 0
0 53 64 **0**	252 121 68
0 65 100 **7**	237 83 0
55 3 14 **0**	114 194 193
100 27 44 **0**	2 109 117
White	255 255 255

CMYK	RGB
26 26 32 **17**	156 141 122
15 18 21 **0**	216 197 179
0 26 100 **0**	255 189 0
82 29 100 **0**	47 112 32
33 100 100 **0**	171 0 0
40 0 0 **100**	0 0 0

100 53 0 **0**		11 76 159
39 0 28 **0**		156 216 174
34 9 81 **41**		99 116 33
0 14 26 **0**		254 219 176
20 27 39 **0**		202 171 133
100 53 0 **50**		4 38 79

7 0 10 **19**		192 201 184
11 11 16 **32**		153 148 134
64 11 51 **60**		37 66 47
White		255 255 255

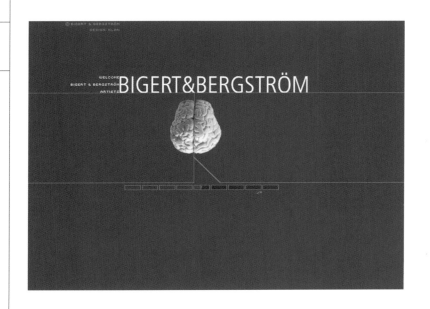

WEB SITE DESIGN Anders Mjöbring, designer for Klan Stockholm. Let me recommend this very artsy Web site for its great Flash graphics, sound and color. I have to admit, though, I still have no idea what it's all about. That's the thing about cool: If you can understand it, it's not cool anymore. Look for Bigert & Bergström's web address in the directory of contributors on page 176 of this book and maybe you can figure it out.

32 55 49 **52**		82 48 45
20 29 100 **17**		170 136 6
34 40 44 **22**		131 103 88
10 17 22 **0**		229 204 179

| 44 49 45 **71** | | 41 31 30 |
| White | | 255 255 255 |

15 0 62 **0**		217 239 99
69 29 8 **0**		82 134 177
14 18 100 **0**		219 219 7
90 68 0 **0**		37 55 150
0 0 15 **19**		207 207 176
White		255 255 255

15 0 62 **0**		217 239 99
69 29 8 **0**		82 134 177
14 18 100 **0**		219 219 7
90 68 0 **0**		37 55 150
0 0 15 **19**		207 207 176
White		255 255 255

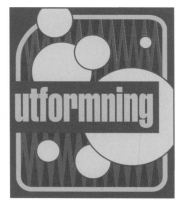

MOVIE POSTER Rohman, designer, 1919. Intolerance obviously is not limited to jaded American film audiences. There was *Intolerance* in Sweden too, with translated subtitles, no doubt. A poster design such as this would never have flown in the U.S. When this D.W. Griffith film was released, painterly realism was the ideal in advertising illustration. Yet the illustration above is timeless and might even pass for a rave flyer.

78 6 33 **18**	47 135 124
21 59 67 **17**	166 80 50
10 4 5 **0**	227 235 232
29 59 67 **44**	101 53 35

40 0 0 **100**	0 0 0
White	255 255 255

50 23 100 **0**	127 150 121
24 20 39 **0**	192 183 137
0 0 0 **45**	140 140 140
50 42 78 **0**	127 115 53
40 0 0 **100**	0 0 0
White	255 255 255

4 37 0 **0**	240 160 206
47 3 4 **0**	136 203 217
79 48 0 **13**	53 82 147
0 75 66 **28**	181 47 39
83 0 100 **24**	33 119 35

7 6 44 **0**	237 233 138
70 6 44 **21**	187 184 109
0 29 100 **0**	255 181 0
69 83 0 **0**	86 34 140
11 100 100 **0**	227 0 0

21 6 31 **21**	158 173 131
21 12 14 **50**	100 103 99
8 33 39 **0**	233 166 129
13 0 0 **5**	211 230 235
White	255 255 255

100 66 0 **0**		13 55 149	
69 45 0 **0**		83 105 175	
0 8 100 **0**		255 235 0	
40 0 0 **100**		0 0 0	
White		255 255 255	

19 12 46 **0**		207 207 129	
41 27 100 **0**		150 150 17	
62 48 0 **0**		100 103 174	
100 88 0 **0**		17 21 133	
40 0 0 **100**		0 0 0	
White		255 255 255	

0 0 0 **20**		204 204 204	
0 0 76 **0**		255 255 62	
0 45 100 **0**		255 140 0	
0 100 83 **0**		253 0 22	
40 0 0 **100**		0 0 0	
White		255 255 255	

13 4 25 **0**		222 232 184	
0 4 25 **0**		255 245 187	
3 8 13 **23**		191 179 163	
53 11 41 **0**		121 178 137	
0 100 100 **0**		255 0 0	
90 90 0 **0**		40 20 133	

WEB PAGE DESIGN Fountain.nu, a Swedish repository of cool fonts created by Peter Bruhn, features the work of designers the world over. Ha! They've even got fonts by dincTYPE from New Jersey. It is a small world, after all. Fountain is an amusing site with humor, romance, passion...! And there are plenty of interesting color combinations to be found there, too.

8 74 100 **0**		235 64 0		44 7 100 **0**		143 188 23	
9 42 100 **0**		232 142 1		57 43 76 **62**		42 41 222	
20 56 100 **13**		178 88 2		White		255 255 255	
18 12 100 **3**		202 199 9					

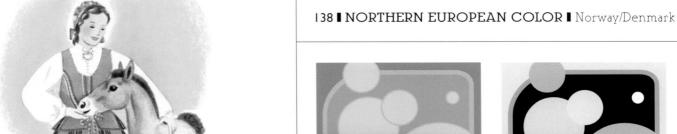

POSTCARD Here is an example of the traditional costume of the Hedemark region of Norway. Continental fashions had a strong influence on traditional folk dress in Norway. Made from wadmal, broadcloth, two-shaft and twill-weave woolen, and linen and cotton fabrics, such costumes undoubtedly kept the wearer warm. However, it looks as though the lady above might have caught herself a little colt.

58 11 3 9		98 162 187	34 16 80 11		150 16 50
0 17 80 0		255 212 47	4 83 100 0		245 43 0
16 33 73 7		198 148 56	24 15 78 9		98 56 17
7 15 32 0		236 211 159	0 4 5 0		255 245 237

33 16 42 0		171 186 133
15 0 9 6		204 226 212
100 0 77 67		0 46 29
19 37 100 0		207 147 6
5 9 100 0		242 226 3
53 27 100 0		120 140 21

90 68 0 0		37 55 150
12 17 0 29		158 144 162
23 5 29 13		171 191 149
0 18 18 5		240 199 180
7 6 25 3		229 226 178
40 0 0 100		0 0 0
White		255 255 255

0 59 100 0		255 105 0
13 51 40 0		218 120 113
29 79 68 0		180 48 51
29 79 68 30		126 34 35
3 17 10 0		248 211 210
40 0 0 100		0 0 0

36 100 87 0		163 0 17
16 33 50 0		213 160 106
51 0 100 0		125 194 28
7 6 41 0		237 233 145
0 20 100 0		255 204 0
40 0 0 100		0 0 0

0 0 0 **20**	204 204 204
74 45 65 **13**	59 83 65
76 57 0 **25**	51 60 121
0 7 38 **0**	255 237 152
7 7 38 **24**	180 175 115
0 53 64 **0**	252 121 68
40 0 0 **100**	0 0 0
White	255 255 255

26 70 65 **0**	187 69 59
39 29 0 **0**	155 155 201
100 25 0 **0**	5 120 179
90 75 0 **0**	38 44 144
3 17 10 **0**	248 211 210
3 3 9 **4**	237 234 218
0 20 87 **0**	255 201 30

90 75 0 **0**	38 44 144
10 3 58 **0**	230 237 106
14 21 83 **0**	218 188 42
14 52 100 **0**	218 114 2

20 17 58 **0**	204 194 99
45 50 86 **0**	140 101 36
13 41 32 **0**	219 143 136
82 53 18 **0**	53 82 138
52 23 10 **0**	123 157 184
45 50 86 **54**	92 67 24
9 5 16 **0**	232 234 205

RUNDETAARN

SOUVENIR SCARF Rundetaarn, or "round tower," is one of those tourist attractions you must see (like the Liberty Bell in Philadelphia) when you visit Copenhagen. Built in the 17th century, Rundetaarn is the oldest functioning observatory in Europe. The tower's messuage includes a chapel and library and a little gift kiosk from which this souvenir scarf (c. 1965) was undoubtedly purchased.

64 0 0 **0**	93 194 219	70 0 60 **4**	71 165 101
0 50 73 **0**	253 128 52	76 0 29 **30**	46 131 120
3 80 100 **0**	247 50 0	40 0 0 **100**	0 0 0
7 3 78 **0**	237 239 58	White	255 255 255

RUG DESIGN The design above, c. 1924, came from a portfolio of prints that I got on loan from the black market in Bucharest. (They're suspicious of foreigners photocopying historic documents, so I had to scan fast.) When I found this selection, I kicked Latvia out of the book to make room for this spread of mouth watering color combinations that made me and some of those black market guys say, "Wow!"

CMYK		RGB
31 46 38 20		140 97 95
24 84 78 27		140 28 24
77 46 29 64		23 35 46
40 25 78 15		130 134 49

CMYK		RGB
0 27 27 0		252 187 161
25 8 35 3		185 202 149
9 81 75 3		222 46 37
10 10 10 10		246 198 71

CMYK		RGB
64 27 100 0		92 130 26
81 27 100 42		28 67 19
24 40 64 0		193 138 76
0 32 21 0		251 174 169
0 78 57 0		250 58 67
White		255 255 255

CMYK		RGB
71 69 0 0		81 59 153
71 100 0 57		36 0 54
29 48 90 0		181 115 25
8 9 10 0		234 225 216
0 45 71 0		253 141 57
27 30 45 0		186 160 118
13 56 34 0		218 108 119

CMYK		RGB
22 35 100 15		169 127 6
18 68 59 21		163 61 55
68 27 88 0		83 129 47
24 40 30 0		192 139 140
18 17 33 0		208 197 53
100 51 29 30		4 53 85

CMYK		RGB
52 7 20 0		123 189 180
100 26 42 0		2 111 121
33 79 100 27		125 34 1
14 66 100 0		219 82 1
White		255 255 255

33 100 72 **21**	134 0 28
71 36 20 **21**	62 93 118
42 23 41 0	148 162 129
26 71 57 0	186 66 70
37 54 35 0	160 101 117
White	255 255 255

0 28 15 **0**	252 185 187
12 70 64 0	22 174 60
5 7 28 0	241 232 176
21 19 24 0	200 190 170
90 57 50 **14**	27 59 77
42 23 69 0	148 160 76

RUG DESIGN Driving toward Bucharest I keep seeing signs for "Bucuresti" and I'm getting nervous because I'm thinking, "I thought this was the #!@%! road to Bucharest!" Then I figure it out and I'm all like, "Why can't we just call each other what we call ourselves?!" Isn't it revolting when a guy says his name is "Roberto" and an American dude with a white belt says, "Gladta meetcha, *Bob*!" Above: dynamite rug, eh?!

31 21 38 **0**	176 176 138	29 60 53 **16**	151 76 70
41 48 51 **30**	150 111 195	51 27 69 **36**	80 92 48
49 22 43 9	119 145 114	26 32 44 0	188 155 118
65 38 41 **59**	37 48 48	44 39 64 **22**	112 99 61

33 48 19 0	170 117 151
59 76 100 0	105 45 13
8 53 9 0	234 116 21
3 21 70 0	246 198 69
52 72 0	123 189 180

59 21 0 0	107 157 201
48 38 100 0	133 123 23
59 21 46 0	106 152 121
11 76 100 0	227 59 9
11 6 14 0	227 230 208
47 38 28 **51**	66 63 69

3 23 58 **0**		246 194 95	
15 66 72 **0**		215 82 49	
18 31 10 **17**		172 137 157	
62 30 51 **0**		98 133 106	
60 10 10 **6**		225 212 203	
18 30 10 **56**		91 72 83	

15 66 100 **0**		217 81 1	
6 23 87 **0**		240 191 32	
26 40 10 **0**		187 139 176	
44 70 88 **10**		129 56 23	
100 53 20 **0**		9 73 132	
8 0 12 **10**		212 223 199	

ILLUSTRATION This 1920s illustration was discovered in a broken frame under a stack of Hungarian newspapers. The image appears to depict a traditional domestic scene involving a dining ritual. The tear on the female Hungarian's cheek indicates that the male Hungarian may have been critical as to the manner of her preparation of the repast. The coloring of the work is starkly appealing in the Hungarian manner.

4 5 73 **0**		245 238 69	
78 3 29 **31**		140 117 110	
5 85 35 **0**		235 41 95	
100 55 0 **30**		18 51 110	

0 20 51 **0**		254 204 113	
0 0 10 **0**		255 255 230	

5 8 17 **0**		241 231 202	
29 16 33 **3**		175 183 147	
9 73 59 **0**		229 68 67	
47 51 54 **44**		76 56 49	
0 44 71 **0**		253 144 58	

30 52 44 **25**		131 80 78	
3 0 49 **0**		247 252 130	
3 18 76 **0**		246 206 57	
0 76 100 **0**		255 62 0	
59 100 33 **49**		55 0 43	
67 39 65 **9**		78 101 71	

46 28 50 **4**		133 143 105
7 56 25 **19**		188 90 110
14 100 50 **48**		111 0 33
7 81 100 **19**		192 38 0
11 7 0 **0**		226 227 240

12 87 43 **41**		128 20 47
64 20 25 **13**		82 133 136
7 58 100 **14**		203 89 0
0 4 8 **9**		232 223 210
28 11 18 **28**		133 146 136

BOX DESIGN Real Hungarian helicopters don't come in boxes because the boxes would be prohibitively large and even 200 lb. test corrugated cardboard would lack sufficient structural integrity. The box design above is just for a *toy* "helicopter" made from stamped tin, with a propeller that really spins! The lovely Hungarian colors on these two pages came from old as well as modern sources, yet there's an amazingly cohesive feeling to the group.

10 10 10 **10**		200 184 128
10 10 10 **10**		121 114 160
40 0 0 **100**		0 0 0
White		255 255 255

100 4 51 **23**		0 109 94
66 0 31 **13**		76 163 140
7 81 71 **19**		190 39 36
0 25 28 **0**		252 192 161
40 0 0 **100**		0 0 0

3 67 78 **0**		245 84 38
78 4 51 **35**		37 107 80
41 0 7 **0**		151 215 217
3 5 94 **0**		247 238 20

100 80 5 **0**		15 33 132
0 85 100 **0**		255 39 0
9 0 7 **0**		232 246 233

0 33 44 0		252 172 119	
6 82 100 0		240 46 0	
0 18 100 0		255 209 0	
48 82 100 0		133 36 3	
40 0 0 100	White	0 0 0	
		255 255 255	

0 51 27 0		250 127 138	
85 35 0 0		45 114 178	
48 82 100 0		133 36 3	
0 18 100 0		255 209 0	

ALBUM SLEEVE I have no idea for what record this record sleeve was made. I forgot to ask for a translation prior to leaving Prague, where I picked this up in a dumpster over on Purkynova Street near the jazz club. It is c. 1965 and shows the influence of the Swiss school of design as well as verges upon a psychedelic aesthetic. (There's something about this that just says "Fillmore Auditorium" to me.)

6 90 0 5		217 27 132	3 8 13 0		246 232 212
27 84 69 23		142 29 36			
69 70 0 5		81 56 145			
40 0 0 100		0 0 0			

0 54 100 0		255 117 0	
7 5 0 42		137 137 142	
87 0 21 15		30 143 146	
7 5 0 12		208 207 215	
40 0 0 100		0 0 0	

11 0 9 25		172 184 171	
56 0 15 42		65 116 113	
17 74 100 0		212 6 11	
51 0 66 14		107 170 81	
27 40 51 0		185 135 100	
6 9 18 0		239 227 198	

0 42 48 **0**		252 149 **105**	
85 35 40 **0**		42 108 **119**	
55 4 74 **0**		115 185 **79**	
39 69 70 **0**		156 66 **53**	
0 11 67 **0**		255 227 **80**	
0 90 100 **0**		255 26 **0**	
White		255 255 **255**	

85 25 12 **0**		43 129 **168**	
100 80 0 **10**		14 30 **125**	
0 11 100 **0**		255 227 **7**	
11 5 0 **39**		139 142 **148**	
0 42 25 **0**		250 149 **151**	

86 0 0 **0**		38 173 **206**	
77 26 0 **0**		63 135 **189**	
33 100 68 **9**		154 0 **37**	
59 0 100 **0**		105 185 **32**	
0 0 23 **0**		255 255 **196**	

11 18 65 **0**		226 199 **83**	
70 11 26 **0**		78 164 **161**	
20 100 91 **9**		185 0 **11**	
38 33 0 **0**		158 148 **198**	
40 0 0 **100**		0 0 **0**	

FOLK COSTUME

Traditional garb of Eastern Europe and the Balkans can be incredibly ornate. Think of it—video games haven't been invented yet and neither has cable TV. What's left to do? You make every tunic into a Sistine ceiling. And there is no truth to the rumor that this guy was rejected by The Village People and went on to start his own band, which became "huge in Europe."

25 78 94 **24**		145 38 **10**	
11 53 58 **3**		218 112 **76**	
92 73 0 **0**		33 46 **145**	
54 14 83 **16**		98 139 **48**	

0 28 93 **0**		255 184 **18**	
44 25 35 **12**		126 138 **122**	
0 83 100 **0**		255 44 **0**	
40 0 0 **100**		255 255 **255**	

BOOK COVER This is the cover design for the Russian version of Joseph Heller's *Catch-22*. The colors look so...Communist. Not *red* I mean, but military in that depressing way in which all human spirit and initiative was pushed down, supposedly for the sake of equality, though in reality the wealthy few swilled vodka and caviar and the rest stood in bread lines. It's amazing how colors will automatically adjust to reflect the contemporary public psyche!

15 14 33 **0**	212 196 149
40 30 17 **4**	148 143 160
44 27 66 **10**	128 134 71
62 47 47 **42**	56 57 59

100 8 30 **0**	1 141 150
16 0 9 **6**	201 223 210
100 0 75 **51**	0 70 45
22 14 13 **10**	179 181 179
90 77 0 **0**	38 40 143
White	255 255 255

0 78 55 **11**	222 51 63
13 10 20 **0**	222 219 190
67 39 27 **15**	74 98 118
White	255 255 255

0 78 100 **14**	219 48 0
90 77 0 **0**	38 40 143
69 14 100 **0**	79 148 33
7 7 100 **0**	237 229 3

0 78 74 **14**	216 49 35
37 13 6 **0**	161 191 208
0 31 26 **0**	252 177 160
9 16 65 **0**	232 206 84
62 67 61 **28**	71 45 49
White	255 255 255

11 7 22 **0**		227 228 189	0 16 27 **0**		253 214 171
13 17 36 **14**		190 173 126	46 57 0 **0**		139 92 170
44 88 67 **25**		107 20 36	81 0 100 **0**		48 158 45
61 36 54 **32**		68 82 66	100 69 0 **9**		12 46 134
40 0 0 **100**		0 0 0	0 90 100 **0**		255 26 0
White		255 255 255	40 0 0 **100**		0 0 0

CD COVER Except for the Russian text, this cover design for *Premiere 3*, a collection of "63 Super Hits," might be mistaken for a similar American product. Ah, but there are the fleeting remnants of those cold, Cold War colors. Wasn't the so-called Cold War really an excuse for our governments to spend our taxes on the arms race? I actually enjoyed the *Super Hits* on this CD, and I think I'll put it on again while writing the rest of these captions.

32 0 52 **0**		173 220 123	13 93 81 **5**		209 19 25
100 85 18 **5**		13 23 106	40 0 0 **100**		0 0 0
57 33 31 **38**		69 82 85	White		255 255 255
74 19 72 **13**		59 121 68			

20 0 15 **0**		204 235 209	0 35 36 **0**		252 167 134
100 5 82 **0**		1 133 78	16 100 100 **18**		175 0 0
40 0 0 **100**		0 0 0	23 64 100 **11**		174 73 10
White		255 255 255	25 29 30 **0**		190 163 149
			40 0 0 **100**		0 0 0
			White		255 255 255

0 85 42 **28**	179 30 61
9 7 19 **0**	232 229 197
72 33 77 **0**	72 116 63
18 22 72 **0**	209 181 66

0 85 42 **28**	179 30 61
8 23 86 **0**	235 189 35
32 50 22 **15**	146 95 122
26 13 0 **0**	189 201 225
40 0 0 **100**	0 0 0
White	255 255 255

MATCHBOOK COVER This striking design is without match. It's a celebration of a factory's 20th year of business. The colors really turn me on and they even look great in the layouts below. Apparently, the design is actually for a factory in Latvia, which is just on the western edge of Russia, about 300 miles from Moscow. Close enough for this book!

11 11 16 **0**	226 218 198		29 34 65 **12**		159 129 67
0 73 100 **0**	255 70 0		40 0 0 **100**		0 0 0
85 41 5 **0**	45 102 165				
37 56 75 **40**	97 57 30				

12 80 100 **18**	183 39 0
0 18 50 **0**	254 209 116
9 39 50 **8**	212 139 94
100 0 100 **60**	0 54 22

100 0 50 **14**	0 127 107
0 0 100 **0**	255 255 0
84 11 0 **0**	44 156 198
White	255 255 255

100 50 0 **0**		10 80 161	
75 7 0 **0**		66 171 206	
0 5 78 **0**		255 242 55	
0 90 100 **10**		230 24 0	
White		255 255 255	

9 10 0 **10**		208 201 214
25 16 68 **3**		185 185 77
36 15 37 **10**		147 167 130
30 43 28 **6**		166 120 129
43 62 41 **9**		132 74 92
68 28 79 **18**		67 104 50
40 0 0 **100**		0 0 0

43 43 100 **4**		139 111 13
6 42 91 **0**		240 144 20
100 28 29 **28**		2 80 99
66 10 18 **5**		84 162 168
40 0 0 **100**		0 0 0
White		255 255 255

11 0 19 **24**		173 186 154
6 0 25 **9**		218 227 172
50 25 0 **0**		128 156 201
11 49 72 **15**		192 106 47
23 45 56 **36**		124 81 56
40 0 0 **100**		0 0 0

MATCHBOOK COVER The illustration shows Ludmila being held captive in the castle of Chernomar, an evil dwarf. It's a scene from the popular Russian fairy tale in poetry, *Ruslan and Ludmila*, by Alexander Pushkin. Brave knight Ruslan, with the aid of a magic sword, overcomes the dwarf and rescues Ludmila who had been placed in a deep sleep by her captor —just like Sleeping Beauty. Has Disney gotten wind of this?

5 15 80 **0**		242 212 49		4 90 90 **0**		244 26 15
30 5 49 **7**		166 197 117		38 4 16 **3**		153 202 189
88 62 12 **28**		29 47 100		40 0 0 **100**		0 0 0
7 85 30 **0**		229 40 102		White		255 255 255

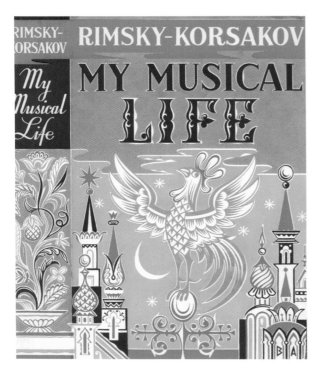

BOOK COVER This is an American book cover by the Russian–American illustrator Boris Artzybasheff for the autobiography of Russian composer Rimsky-Korsakov. So I think it qualifies for the Russian section. The colors are of a typical Russian style. Artzybasheff was that rare commercial artist: a hard-edge designer, a visionary nut and also a serious painter, famed for his TIME cover portraits in the 1940s.

22 21 74 **16**		167 152 53		
0 88 100 **0**		255 32 0	0 0 18 **0**	255 255 209
100 80 0 **12**		14 29 122		
45 5 42 **0**		141 197 140		

48 22 50 **29**		95 113 180	
0 60 100 **0**		255 102 0	
100 47 0 **13**		9 74 142	
40 0 0 **100**		0 0 0	
White		255 255 255	

40 22 60 **10**		138 149 85	
30 90 100 **15**		152 19 0	
5 6 0 **20**		193 188 196	
40 0 0 **100**		0 0 0	
White		255 255 255	

10 10 10 **10**		121 89 75	
10 20 65 **0**		229 196 81	
40 0 0 **100**		0 0 0	

10 10 0 **22**		179 173 185	
6 94 66 **0**		236 19 46	
40 0 0 **100**		0 0 0	

38 75 100 **0**		158 53 4
81 29 100 **0**		48 112 32
22 43 100 **0**		199 130 6
28 44 12 **0**		182 129 167
0 4 18 **0**		255 245 205
40 0 0 **100**		0 0 0

15 100 66 **0**		214 0 43
0 4 18 **0**		255 245 205
0 5 18 **25**		191 181 152
44 5 50 **52**		69 94 59
44 5 55 **25**		107 147 86
40 0 0 **100**		0 0 0

WOODEN TRIVET This design, hand painted on a wide assort-
ment of kitchenware, comes out of a small village 62 miles
(100 kilometers) from Moscow. The artisans have been doing
it this way for at least 200 years. Layers of golden shellac
lend richness to their designs. Before I left, I surreptitiously
dropped rave flyers from Berlin all around town. I want to
go back in five years and see if anything's changed!

7 47 100 **0**	237 131 1		3 100 100 **0**	247 19 10
16 100 100 **3**	207 0 0		23 68 100 **35**	127 58 2
84 34 100 **34**	28 67 20		40 0 0 **100**	0 0 0
39 36 100 **4**	150 128 13		White	255 255 255

0 58 100 **6**		240 101 0
16 85 100 **0**		214 36 0
100 20 55 **0**		1 118 107
40 0 0 **100**		0 0 0
White		255 255 255

20 11 100 **0**		204 206 10
8 82 34 **8**		210 43 91
23 58 84 **0**		195 96 33
12 29 0 **69**		68 54 66
White		255 255 255

If you want to experience the true meaning of Paradise, you'll find it in places like Bali, Tahiti and Hawaii. But hurry! Paradise is quickly becoming lost as the march of civilization trudges ever forward. ■ The Balinese still take their twilight ablutions in any convenient stream, though the waters have become increasingly polluted with commercial refuse. ■ I can't forget the discarded Dunkin Donuts bag I saw lying on the ground so incongruously before a breathtaking Hawaiian landscape. ■ I've always disliked antique shops in which all the treasures have already been "found:" cleaned up and displayed prissily in glass display cases. Hawaii reminds me of such a shop. Admittedly, the islands are beautiful, but a little too manicured for my taste. ■ Tropical islands are a riot of color, with enormous, flaming blossoms and lush foliage everywhere you look. But there's only so much red, yellow and blue a book like this can present before redundancy sets in. Luckily there are also the stormy colors, and the earth colors of the islands that we have mainly focused on in this chapter. ■ In 1947, after evacuating people who didn't matter, we dropped a big one on the Bikini atoll and blew it to smithereens. There's "processing" for you: we named a bathing suit after the tragedy to soothe our consciences. Fifty years later they're cautiously resettling the island—which is a relief. Atom bombs aren't all *that* devastating! ■ There are two Cubas; the dismal embodiment of Communism's failure we're told about, and the plucky little island doing just fine by itself, despite its solipsistic leader. In the absence of Western pharmaceuticals, many Cubans have gone back to the women healers for time-honored herbal remedies. Tell me, who's the poorer?

ND

COLOR

FABRIC DESIGN The fabrics of Indonesia are widely admired for their exuberance, variety of patterns and gorgeous colors. Balinese textiles support an army of exporters from other countries who come to bargain for the inexpensive goods that can be sold at great profit elsewhere. The above fabric, used on some drawstring pants, combines a hand-made batik pattern with tie-dyed cotton. I never had the nerve to wear the pants after I got back to America.

0 25 100 **0**		255 191 0
3 4 72 **0**		247 242 71
52 3 63 **3**		119 185 196
13 68 79 **43**		125 44 21

10 10 10 **10**		133 41 83
86 32 8 **40**		25 70 101

27 50 61 **50**		92 56 38
6 58 78 **0**		238 105 41
0 3 28 **0**		255 247 181
20 30 36 **22**		158 127 105

0 40 80 **0**		254 153 41
20 35 85 **15**		173 129 31
0 100 76 **38**		156 0 19
0 80 60 **20**		200 42 49
36 63 85 **24**		124 60 24

15 90 100 **7**		201 23 0
44 90 100 **0**		143 21 1
100 55 11 **33**		6 48 96
22 60 80 **0**		198 92 38
5 16 36 **0**		241 210 149

11 88 100 **14**		195 26 0
11 55 80 **0**		226 110 39
20 90 100 **67**		67 8 0
White		255 255 255

CMYK		RGB
31 0 8 **27**		129 164 160
47 43 44 **53**		64 55 51
29 48 88 **16**		152 97 25
4 26 57 **0**		244 186 96

CMYK		RGB
17 74 86 **6**		199 58 23
0 43 74 **6**		238 137 49
17 90 100 **65**		74 8 0
59 30 32 **8**		98 126 127
15 13 23 **0**		216 209 179

CMYK		RGB
38 100 90 **0**		158 0 13
14 84 70 **0**		216 40 45
0 61 100 **4**		245 95 0
32 12 77 **0**		173 192 64
0 19 56 **0**		254 207 102
40 0 0 **100**		0 0 0

CMYK		RGB
100 77 0 **61**		4 15 55
58 36 0 **35**		71 83 121
11 48 100 **0**		227 126 2
4 10 17 **0**		244 229 201

FABRIC DESIGN Bali is divided into specialty towns. There's the silver jewelry-making town, the gold jewelry town, and towns that specialize in cheap woodcarvings, expensive woodcarvings, paintings, musical instruments and various fabrics. I asked about an African-looking mask at one shop and the owner told me, "Oh we just get a book of African masks and copy them." The batik fabric above looks faux-Mayan to me, but the Balinese also have their own exotic motifs!

CMYK		RGB		CMYK		RGB
35 83 0 **0**		164 41 144		12 82 80 **33**		149 30 21
95 96 10 **4**		28 11 111		16 70 65 **62**		80 28 22
0 11 45 **0**		254 227 132				
0 66 100 **0**		255 87 0				

PAINTING I'm in Ubud, Bali and a local woman dashes up and tries to sell me some original watercolor paintings. I look at them. They're fantastic, meticulous, skillful. I bargain her down to seven dollars—an absurd price for original art, but a week's wage for many Indonesians. Later I feel ashamed, but then I find comparable art for five dollars and feel I've been cheated! I couldn't get used to the bargaining.

0 22 43 **0**		253 199 129	
27 8 9 **3**		180 204 204	
4 74 69 **0**		242 66 50	
13 4 19 **0**		222 233 198	

29 30 46 **31**		124 950 76	
38 3 31 **0**		158 209 165	
5 41 63 **0**		240 147 75	
78 9 21 **20**		46 129 135	

70 39 20 **11**		71 101 132	
100 55 20 **40**		4 42 79	
11 55 80 **0**		226 110 39	
5 7 14 **5**		229 221 198	

11 75 65 **10**		202 56 50	
0 45 50 **15**		214 120 84	
85 35 0 **20**		36 91 142	
30 33 64 **10**		161 135 72	
3 6 18 **0**		247 237 202	

47 73 0 **0**		136 59 153	
6 66 0 **0**		232 88 169	
60 27 42 **0**		103 140 123	
0 22 100 **0**		255 199 0	
16 91 100 **0**		214 22 0	
White		255 255 255	

55 83 26 **13**		102 31 93	
23 10 7 **0**		196 210 215	
23 14 78 **0**		196 196 58	
54 19 79 **0**		117 157 63	
38 52 20 **13**		137 91 125	

CMYK	RGB		CMYK	RGB
0 35 35 **5**	239 158 130		0 18 100 **4**	245 201 0
5 0 50 **25**	181 187 95		11 77 77 **0**	225 57 37
0 60 40 **30**	175 73 75		33 17 0 **7**	159 173 202
60 0 100 **40**	61 110 20		77 66 44 **17**	53 50 77
			4 7 15 **0**	244 234 208

CMYK	RGB		CMYK	RGB
50 100 70 **0**	128 0 36		4 33 100 **0**	245 168 1
11 37 100 **5**	215 145 2		0 94 92 **22**	198 15 9
0 57 88 **0**	254 110 23		60 24 100 **24**	78 106 19
0 94 92 **9**	231 17 11		50 6 7 **4**	232 226 219
50 6 7 **4**	232 226 219		40 0 0 **100**	0 0 0

DECORATIVE PRINT Java has a variety of attractions including temple sites; beautiful, unspoiled beaches; awesome volcanoes; picturesque highland lakes; and fantastic wildlife reserves. Much Javanese design is highly stylized so as not break the laws of Islam which forbids depicting the human figure. You almost can't see the beady eyes and gaping maws emerging from the center of this image. Oops, I told!

CMYK	RGB
7 20 76 **4**	227 190 55
100 68 28 **29**	6 35 79
24 65 88 **15**	165 68 21
24 4 16 **6**	183 209 189

HAND-PAINTED TIE

Though white missionaries gleefully introduced the concept of shame to Hawaii's shores, they couldn't prevent the kind of crassly prurient commercial exploitation resulting in this 1940s tie design. But, for the mature student of anatomy who requires an uncensored view of this grass-skirted vixen, we make the following offer: Send one dollar and an e-mail address to Aloha Tie, P.O. Box 48524, Los Angeles, California 90048. Our guarantee: *Nothing* will be left to the imagination!

CMYK		RGB
24 62 73 16		162 73 44
3 23 33 0		245 194 151
56 27 22 0		113 145 158
0 10 77 0		255 230 57
0 58 55 0		251 108 82
17 57 44 0		209 104 101
55 48 50 60		46 41 38
0 0 42 0		255 255 148

CMYK		RGB
3 41 0 3		234 145 195
70 0 36 0		78 183 151
0 3 28 0		255 247 73
100 33 10 22		4 83 125
65 24 0 0		92 147 196
White		255 255 255

CMYK		RGB
53 65 36 0		122 71 106
20 36 20 0		202 151 162
20 82 79 0		203 43 33
0 58 85 14		218 92 24
0 27 61 0		254 186 86
9 0 60 31		160 169 71
9 8 60 56		102 99 43
40 0 0 100		255 255 255

CMYK		RGB
28 7 10 5		175 201 199
6 12 26 0		239 219 176
53 26 26 17		101 124 127
32 90 54 0		171 24 64
17 36 45 0		210 152 114
79 36 36 38		36 69 77

CMYK		RGB
51 59 22 16		106 71 111
0 56 29 0		249 114 130
12 15 15 0		223 207 196
29 38 41 0		180 140 119
62 0 36 50		49 95 76
33 0 18 29		122 158 140

11 17 30 **0**		226 203 162	
10 25 66 **15**		195 156 66	
7 20 24 **25**		176 149 129	
26 66 50 **60**		75 32 34	
White		255 255 255	

100 69 0 **14**		12 43 126	
15 100 54 **16**		178 0 49	
73 34 100 **8**		64 102 24	
0 6 43 **17**		212 199 117	
21 10 0 **0**		200 212 232	
17 38 67 **0**		211 147 70	

65 31 0 **0**		92 134 189	
17 8 16 **9**		193 200 181	
42 8 19 **15**		126 167 157	
3 58 15 **26**		178 80 113	
3 72 15 **0**		239 73 138	
White		255 255 255	

0 20 71 **4**		244 196 64	
80 0 12 **0**		52 177 189	
0 100 64 **0**		250 0 46	
92 0 79 **26**		17 111 61	
21 0 0 **30**		141 165 171	
40 0 0 **100**		0 0 0	
White		255 255 255	

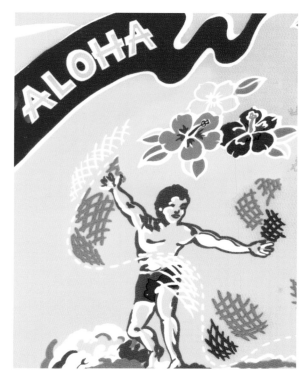

HAWAIIAN SHIRT Nothing typifies Hawaiian design more than the "aloha" shirt. The model above, c. 1960, has it all: tropical flowers, a buff young surfer, crosshatched motion lines, sea foam and a banner emblazoned with the word *aloha*—a greeting that works coming or going. Many shirts use dark, stormy color combinations, as evidenced by the swatch sets on these two pages that were taken from Hawaiian shirts.

0 13 63 **0**		254 222 88	
92 71 12 **0**		32 49 131	
63 36 0 **0**		97 125 185	
14 100 73 **0**		216 0 34	

56 25 100 **0**		112 141 23	
White		255 255 255	

PAINTING Jean Léon Laurenceau, artist. I wish we'd just leave Haïti alone and let them have a populist government. But no, the island is way too "strategic." Meanwhile, artists like Laurenceau are part of a thriving art scene producing works that have become highly collectible. Haitian art is mostly folk art in a naïve vein. If you look at a variety of Haitian paintings, most seem to have a similar range of colors. One exception is the double diptych, opposite page.

78 53 12 **4**		60 81 142
57 5 30 4		111 187 162
4 26 80 4		235 178 44
53 26 86 **39**		74 88 29

35 18 89 **9**		151 160 35
69 21 58 **14**		69 122 86
16 80 94 **4**		205 46 12
5 9 60 **4**		232 218 94

88 37 11 **0**		37 107 159
27 8 30 **0**		186 210 166
41 3 14 **51**		74 102 98
51 72 5 **22**		99 46 114
0 100 75 **15**		214 0 27
40 60 0 **80**		0 0 0
White		255 255 255

65 28 0 **13**		80 122 167
11 44 0 **0**		222 139 195
12 40 100 **7**		208 134 2
100 50 59 **0**		3 73 82
0 100 100 **15**		217 0 0
43 79 100 **0**		145 43 4
White		255 255 255

16 22 61 **0**		213 186 90
14 36 0 **46**		116 84 110
14 36 100 **36**		140 97 2
20 24 21 **0**		203 179 172
36 71 100 **0**		163 62 5
40 0 0 **100**		0 0 0
White		255 255 255

10 17 14 **23**		176 157 151
10 38 100 **23**		177 116 1
15 52 38 **0**		214 116 115
12 12 38 **0**		223 213 147
36 91 65 **0**		162 21 49
37 56 14 **23**		123 75 115
40 0 0 **100**		0 0 0
White		255 255 255

11 88 0 **0**		217 34 142	
11 88 100 **0**		227 30 0	
0 28 100 **0**		255 184 0	
45 12 100 **0**		140 177 22	
100 63 0 **25**		10 45 113	
20 16 10 **18**		166 162 167	

33 63 100 **0**		171 80 6	
11 25 12 **0**		225 184 192	
13 29 65 **0**		221 171 78	
20 73 37 **0**		200 65 101	
2 18 13 **0**		201 216 205	
51 3 70 **56**		55 85 38	

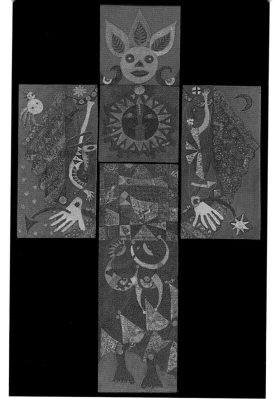

PAINTING Genevieve L. Esper (Iris), artist. "The Universe, as I perceive it, is the source of my inspiration," says Iris of her powerful work. "My choice of colors depends on what emotions rebound from the canvas. The strong colors of the sea, the flowers and the vibrant characteristics of the Caribbean are predominant in my paintings." This is titled *Le Roi Soleil*.

14 88 71 **16**		181 26 35	
85 12 21 **7**		38 139 152	
24 31 60 **7**		179 147 82	
93 89 6 **5**		31 18 119	

10 26 100 **6**		216 170 2	
63 19 59 **43**		54 86 57	

50 10 100 **0**		127 176 25	
9 42 100 **0**		232 142 1	
60 52 0 **15**		90 82 145	
39 80 100 **0**		156 42 3	
67 44 100 **17**		70 82 17	
7 10 19 **0**		236 224 195	

0 55 15 **0**		248 117 157	
0 75 61 **3**		243 64 60	
65 25 77 **0**		90 136 66	
54 47 0 **13**		104 95 154	
9 42 100 **0**		232 142 1	
4 10 42 **0**		244 226 140	
40 0 0 **100**		0 0 0	

MINISTERIO DE CULTURA DE CUBA
Sitio Espejo **www. cult.cu**
EL SITIO DE LA CULTURA CUBANA
Copyright 2000. Cubarte. Todas los Derechos Reservados.

WEB SITE DESIGN Rodolfo Delgado Hernandez, designer. If ever there was a Cuban rainbow, it is this one that comes alive on the Internet in a Flash-animated sequence for Cubarte. The colors have been beautifully tweaked until they virtually reek of old Habana. Hernandez, also a talented surrealist painter in a style reminiscent of Dali, admits "the world of color is extensive and not so simple as people usually think. My work results from playing with the colors."

56 21 87 **20**		90 120 38
18 13 100 **4**		201 195 9
0 66 93 **0**		254 88 14
0 54 32 **0**		250 119 26

83 55 0 **0**		52 80 162
100 77 0 **0**		15 38 141
60 75 0 **0**		106 52 149
White		255 255 255

43 81 25 **28**		105 30 79
78 29 100 **0**		56 115 31
5 30 100 0 **6**		242 175 1
16 0 **0**		238 210 232
25 61 100 **0**		191 88 4

13 87 100 **0**		222 32 0
5 16 57 **0**		241 210 102
38 79 17 **0**		157 48 124
38 37 56 **0**		158 135 93
0 43 100 **8**		235 134 0

0 16 50 **0**		254 214 117
54 59 0 **0**		119 85 166
75 59 0 **37**		45 48 101
63 15 85 **0**		95 155 56
40 0 0 **100**		0 0 0
White		255 255 255

6 56 73 **0**		238 110 50
85 0 0 **0**		40 174 207
0 38 16 **0**		250 159 173
0 100 78 **0**		252 0 28
40 0 0 **100**		0 0 0

21 13 40 **0**			201 203 141		
66 28 75 18			72 107 56		
40 0 0 **100**			0 0 0		
White			255 255 255		

47 7 17 **0**		136 194 188
90 23 60 18		23 99 79
51 82 100 0		125 36 4
22 34 100 0		199 151 8
14 85 90 11		194 33 14
6 10 43 7		222 209 128

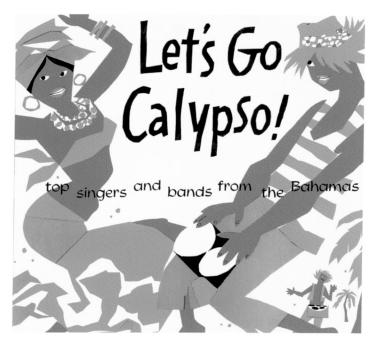

Let's Go Calypso!

top singers and bands from the Bahamas

ALBUM COVER Here is an illustration with a nice composition and beautifully drawn, abstracted figures. The colors go well with the calypso and reggae music featured on the album which is softer and warmer than the harder-edged and abrasive salsa and Afro-Cuban styles. In fact, according to my wacky, color-as-music theory (see page 12), the colors above are perfectly matched to the music of the Bahamas.

55 0 100 **0**		115 190 30	40 0 0 **100**		0 0 0
40 45 85 9		139 104 35			
0 68 82 0		253 83 31			
0 0 20 **0**		255 255 204			

5 59 0 **0**		234 105 178
0 8 81 0		255 235 47
63 3 100 0		94 176 34
18 100 0 0		200 2 127
100 59 0 7		11 62 144
100 8 24 0		1 142 158
White		255 255 255

70 13 0 **0**		79 164 204
77 42 0 0		65 106 175
0 0 72 0		255 255 71
0 46 72 0		253 139 55
40 0 0 **100**		0 0 0
White		255 255 255

32 37 20 **50**			86 71 **79**	
38 58 58 0			158 90 77	
10 10 28 0			229 221 173	
9 31 36 0			230 170 137	
40 0 0 **100**			0 0 0	

68 0 13 0			83 188 193	
80 50 0 0			58 90 167	
100 83 0 0			16 28 137	
0 25 100 0			255 191 0	
6 18 28 0			0 0 0	

PAINTING Pierre L. Torres, artist. Entitled *Together*, this piece is an oil painting on wood with a central panel made of coral sand from the lagoon. According to the artist, it depicts two figures, feminine and masculine, locked in love's embrace. Surrounding this are several motives inspired by Pascuan symbols discovered on ancient stone carvings.

11 49 53 3			217 121 88	
3 23 31 0			245 194 155	
27 60 60 **27**			135 66 53	
54 44 9 **6**			112 108 156	

44 62 44 **49**			73 41 49	
20 49 54 **10**			183 108 80	
68 17 45 **10**			75 137 112	
3 9 17 0			246 229 201	

25 12 0 0			191 203 226	
6 32 75 0			239 169 55	
19 14 55 0			207 202 108	
49 25 0 **17**			109 130 168	
3 10 22 0			246 227 188	
49 25 0 **55**			59 71 91	

11 46 0 **48**			116 70 100	
17 85 42 **48**			150 28 61	
4 8 20 0			150 197 183	
3 7 25 0			246 234 183	
84 16 41 0			44 140 130	
11 46 56 **29**			160 94 61	

CMYK	RGB
0 24 94 **0**	255 194 17
14 69 100 **0**	219 74 1
17 35 0 **5**	198 149 193
78 50 0 **25**	47 68 125
29 0 0 **0**	181 227 238
14 79 100 **41**	129 30 0

CMYK	RGB
49 0 33 **0**	130 205 161
72 11 100 **43**	40 86 20
49 0 88 **0**	130 198 52
0 19 60 **0**	254 207 92
8 52 50 **14**	199 102 80
40 0 0 **100**	0 0 0

CMYK	RGB
47 50 29 **32**	92 71 88
60 40 17 **32**	71 80 105
40 24 54 **12**	135 142 91
17 22 33 **0**	211 186 149
5 0 23 **0**	242 250 194
40 0 0 **100**	0 0 0

CMYK	RGB
100 62 0 **0**	12 61 152
69 6 0 **0**	80 178 210
0 13 100 **0**	255 222 0
0 13 100 **20**	204 178 0
23 13 100 **32**	133 134 777
40 0 0 **100**	0 0 0
White	255 255 255

PAINTING Pierre L. Torres, artist. Moroccan-born Torres spent many years in Tahiti immersed in the island's history its culture and theology. His painting is designed to be viewed both in portrait and landscape modes.

Torres explains, "Viewed upright, the god Tiki stands at left, holding an animal with a long tail. At right, a gecko opens his eyes. The blue could be an opening to the sky. Horizontally, the Tiki seems blown up from the painting. A black skull becomes the main focal point. Look again, the gecko is still there, climbing the back of a wild, primitive animal with a long blue tongue."

CMYK	RGB
13 77 0 59	131 155 150
28 59 56 25	43 28 25
47 23 27 3	255 247 209
48 58 58 68	
0 3 17 0	

CMYK	RGB
12 43 56 3	215 128 90
21 83 83 9	182 37 24
18 21 42 0	208 186 131
73 35 10 3	71 116 162

36 9 43 **17**		136 164 113		23 0 30 **0**		195 231 174
0 12 28 **9**		231 204 157		54 13 100 **0**		117 166 30
0 3 28 **0**		255 247 181		46 72 100 **10**		124 51 5
20 81 77 **22**		158 35 28		19 13 33 **0**		207 205 157
				13 37 93 **0**		222 150 20

ALBUM COVER Tahitian stock photography with a bit of color enhancement gives this record album cover its allure. The image is so vivid that it might just have been created from a large format camera on a Hollywood set, and the color has that weird/cool, old-fashioned quality. I like the deliberate accent of the pink lei, and the great script lettering that didn't come from the Adobe Type Library, but from a guy with a brush!

3 30 47 **0**		246 199 121		20 0 60 **0**		229 166 60
24 0 16 **0**		194 231 205		38 35 80 **43**		90 78 28
0 50 20 **0**		249 129 153		5 0 19 **0**		242 250 205
0 100 100 **0**		255 0 0		30 21 66		156 152 71

9 12 9 **0**		231 217 214		0 100 100 **0**		255 0 0
0 44 59 **66**		86 49 28		0 35 40 **0**		252 167 126
0 21 45 **32**		172 137 85		0 7 58 **0**		255 237 103
46 29 0 **0**		139 151 199		0 17 100 **20**		204 170 0
13 22 0 **0**		220 190 221		27 63 36 **14**		158 73 94
				0 36 100 **35**		166 106 0
				White		255 255 255

42 87 58 0		255 194 0
6 12 14 0		239 219 203
3 24 70 0		249 193 68
28 23 0 x0		183 176 213
88 66 0 0		42 59 152
87 28 0 0		39 125 183

100 42 10 13		6 80 134
29 7 0 3		175 205 223
30 71 100 0		179 64 3
40 0 0 100		0 0 0

44 8 21 0		144 195 180
61 28 0 0		101 143 194
29 39 28 23		138 107 110
29 39 28 64		65 50 52
White		255 255 255

24 80 73 0		192 46 42
42 25 79 21		117 122 45
15 42 84 7		201 129 34
71 24 37 22		59 108 104
13 10 0 0		221 219 236

SELF-PORTRAIT Mathius, artist. Maybe Tahiti is like San Francisco. So many of its denizens weren't born there—they arrived there. Thirty years ago, Mathius left France and arrived in Tahiti in pursuit of his muse. His colors come from the light of a certain moment, or from "a thing that impresses me." Like its other artistic émigrés, Mathius has made Tahiti his, adopting its colors and symbols.

6 72 0 0		23 173 162
33 45 58 44		95 68 477
33 40 36 17		141 111 105
59 0 9 0		106 198 204

0 13 93 0		255 222 20
0 57 100 0		255 110 0
44 0 100 0		143 203 24
0 85 100 0		255 39 0

MIDDLE EA

One can't think of the Middle East without thinking of the word "conflict." There's been so much of that in this historic region that is home to a multitude of cultures and traditions and which, coincidentally, has lots of oil: black gold, Texas tea. ■ The colors of the Middle East are as brilliant and manifold as the rainbow-like reflections on the oil slicks left behind by bloated tankers listing drunkenly through the Persian Gulf. ■ As I walked through the bustling, modern streets of Tehran, admiring the amazingly complex and colorful tilework adorning mosques and public buildings, my thoughts ran to Iran's vast Dasht-i-Kavir salt desert that I'd recently traversed, with its single color of 0C/10M/35Y/10K. ■ Everywhere I went—Syria, Lebanon, Iraq, Armenia, Saudi Arabia, etc.—my eyes feasted upon beautiful color combinations. I could go on waxing rhapsodic about the colors of the Middle East, but I am struck with the realization that there are marvelous color combinations to be found in *every* corner of the globe and in this regard no single country can claim superiority over another. If our world leaders would apply this simple truth broadly, we'd have universal love, peace and color harmony. But they won't, and that must be why *they're* the "leaders." ■ W. B. Yeats explained it perfectly: "The best lack all conviction, while the worst are full of passionate intensity." ■ What, you may be asking by now, has my running diatribe against world governments to do with color? We artists have always been truth-seekers (aside from guys who draw clip art). When you spend so much time asking yourself, "Why do the clouds I've painted seem so lopsided?" you eventually start to wonder why the world too seems so lopsided.

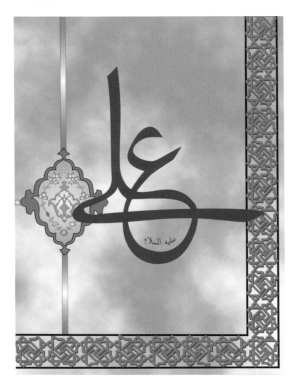

POSTER Maryam Heidari, designer for Pooyesh.com. The large calligraphy in the center of this piece spells the name of "Ali," the first Imam (leader) of the Shiite Muslims. The smaller text reads, "Peace be with him." Heidari painted her initial design in watercolor and then scanned it into the computer for finishing touches. "The greenish theme," the artist explains, "symbolizes 'peace' in Islam."

35 0 15 **15**		207 159 124
30 70 70 **25**		56 130 34
0 15 50 **5**		208 70 92
20 30 70 **30**		206 145 55
0 5 20 **3**		0 0 0

0 12 34 **16**		213 188 132
100 63 0 **36**		8 38 97
55 38 0 **0**		117 127 186
37 67 100 **0**		161 70 6
28 16 85 **0**		184 187 44

18 33 55 **0**		208 158 96
40 22 72 **11**		136 146 63
16 88 100 **0**		214 30 0
70 42 20 **20**		64 87 117

25 64 94 **19**		155 66 13
40 0 0 **100**		0 0 0
7 14 30 **0**		236 213 165

16 5 22 **0**		214 227 189
49 11 0 **0**		131 186 216
47 79 18 **19**		110 37 99
38 44 27 **16**		132 103 117
20 55 16 **14**		172 92 130
18 22 7 **0**		207 186 204

16 11 11 **0**		213 213 208
4 36 17 **0**		241 162 173
12 90 85 **0**		222 23 22
38 0 41 **0**		158 215 146
45 15 100 **0**		140 171 21
27 40 100 **0**		186 134 9
40 0 0 **100**		0 0 0

64 24 13 **0**		94 147 174	
18 4 67 **0**		209 226 86	
36 34 0 **0**		162 146 197	
37 67 100 **0**		161 170 6	
62 0 79 **14**		84 158 63	
8 11 0 **0**		234 221 237	

56 64 0 **0**		115 74 161	
47 20 64 **7**		126 151 82	
37 100 100 **0**		161 0 0	
18 30 67 **0**		208 165 74	
74 22 100 **11**		59 116 28	

17 100 53 **10**		189 0 54	
83 29 0 **41**		28 74 108	
40 0 33 **0**		150 213 163	
70 10 63 **0**		78 161 98	
56 47 100 **0**		112 100 16	
14 27 100 **0**		219 174 5	
White		255 255 255	

20 56 39 **11**		179 93 99	
26 57 100 **22**		147 76 3	
6 24 76 **0**		239 189 55	
100 0 43 **18**		0 123 112	
12 85 100 **0**		224 37 0	
40 0 0 **100**		0 0 0	

FABRIC DESIGN The Persians are said to have invented such patterns consisting of decorative strips laid edge-to-edge, as in the 1880s print above. They would have influenced the Victorians, always fascinated by styles from "exotic" locales, especially when effusively detailed. It would appear from this style of fabric that the granny dress fabrics of the 1970s may have had roots in the Persian empire.

6 17 77 **0**		240 207 56	
33 16 31 **0**		171 186 156	
83 55 13 **33**		3 76 103	
60 20 42 **30**		72 108 90	

28 29 80 **13**		160 138 44	
25 58 67 **42**		110 56 36	
20 90 85 **11**		181 22 20	
White		255 255 255	

PAINTING Ismail Shammout, artist, 1969. *The Candles* was inspired by the suffering of thousands of Palestinian children after the Israeli occupation of the West Bank and Gaza District in 1967. While "leaders" grab for land and oil, children—like the 4,500 Iraqi children who perish each month (as reported by UNICEF) due to U.N. sanctions—continue to suffer. And artists like Shammout continue to record such events with stirring sensitivity and compassion.

CMYK	RGB	CMYK	RGB
19 0 39 0	207 235 153	50 15 100 7	118 154 22
13 24 76 4	213 176 55	0 67 91 0	254 85 16
27 9 0 0	186 209 229	73 19 16 9	65 135 155
0 23 94 0	255 196 17	0 42 37 0	251 149 127

CMYK	RGB	CMYK	RGB
17 45 89 7	197 120 24	0 74 56 0	250 68 70
37 6 19 0	161 206 188	0 18 85 0	255 209 36
81 4 23 9	45 152 153	63 25 100 40	57 81 16
26 90 100 25	141 17 0	24 91 96 16	162 18 7
74 42 30 40	41 61 76	0 50 78 0	253 127 42
77 35 79 15	50 91 50	91 56 14 14	27 63 120
		40 0 0 100	0 0 0

CMYK	RGB	CMYK	RGB
27 100 100 0	186 0 0	87 25 19 20	30 101 126
20 80 10 32	138 147 144	13 6 7 9	202 208 204
0 4 27 0	255 245 182	50 32 0 0	128 141 194
8 25 17 0	233 186 183	4 4 47 0	245 241 132
40 0 0 100	0 0 0	40 0 0 100	0 0 0
White	255 255 255	White	255 255 255

9 0 42 0			232 246 147	
86 100 0 0			51 0 124	
47 33 50 0			135 138 106	
68 49 88 0			83 90 138	
White			255 255 255	

0 6 17 0		254 240 206
12 54 76 0		223 111 46
80 35 59 13		46 95 79
0 8 56 17		212 195 89
54 100 16 0		120 0 105
40 0 0 100		0 0 0

PAINTING Ismail Shammout, artist, 1970. *In a Refugee Camp* is the title of this work that was painted in the Mar-Ilias Palestinian refugee camp in Beirut. The artist painted many of this type after being uprooted from his home. Creating such beauty amidst tragedy reminds me of the many musical compositions created by Jews while imprisoned in Nazi concentration camps. What's that phrase—the call for remembrance and determination? *Never again!* I wonder if those words apply to Palestinian refugees?

46 8 38 0		139 191 146	0 16 76 0		255 214 57
24 67 80 14		166 65 31	10 0 12 0		230 245 220
68 24 65 25		62 101 64	40 65 60 50		76 37 35
24 73 34 10		172 58 95	33 10 74 0		171 197 71

60 22 95 3		158 81 144
67 26 43 25		169 25 78
26 72 90 18		255 235 98
12 22 94 0		255 84 0
7 72 86 6		234 228 222
68 42 49 54		77 13 62
5 4 27 0		77 13 62

6 13 11 9		217 198 191
35 100 44 30		115 0 50
17 47 6 15		175 108 152
40 0 0 100		0 0 0
White		255 255 255

13 43 71 **0**		221 137 62	
16 85 100 **14**		184 31 0	
78 27 24 **0**		59 129 150	
9 16 63 **0**		232 206 88	
40 0 0 **100**		0 0 0	
White		255 255 255	

13 70 91 **4**		212 68 16	
4 7 16 **0**		244 234 205	
88 28 90 **0**		32 110 48	
9 16 63 **0**		232 206 88	
40 0 0 **100**		0 0 0	
White		255 255 255	

RUG DESIGN Since ancient times, Armenian crafts were considered "primo" trade items throughout European and Eastern markets. Foremost among these crafts was carpet making, the most important form of weaving. Armenia may well be the birthplace of the rug and there is evidence that the word "carpet" comes from the Armenian *kapert* ("ka"—place, and "pert"—piece). The runner above was made in 1913.

14 88 87 **4**		209 29 19	
54 11 41 **11**		105 157 121	
44 33 57 **33**		96 93 63	
0 15 47 **0**		254 217 1255	

0 64 90 **0**		254 93 18	
46 51 44 **59**		57 42 43	
20 71 85 **9**		185 62 25	
13 33 66 **3**		214 157 72	

4 38 37 **0**		242 156 109	
17 31 81 **14**		182 134 38	
17 31 81 **38**		131 86 26	
21 74 72 **0**		199 61 46	
21 74 72 **66**		68 21 16	
3 7 24 **5**		234 222 177	

80 5 5 **15**		45 144 167	
23 94 84 **0**		195 17 22	
8 30 100 **10**		212 156 2	
40 0 0 **100**		0 0 0	
White		255 255 255	

25 40 78 **0**		190 136 49
10 100 82 **18**		187 0 19
100 40 0 **75**		124 42
70 5 5 **0**		237 236 232

11 15 32 **0**		226 208 158
0 22 56 **7**		236 185 93
31 80 60 **0**		174 45 61
40 8 27 **11**		137 176 150
12 46 100 **12**		198 115 2
39 100 85 **42**		90 0 11

BLACK VELVET PAINTING Elvis and astrological love signs are not the only subject matter worthy of black velvet. The scene above portrays a symbolic water bearer in a costume from the Yerevan region. Behind her looms Mt. Ararat (the resting place of Noah's ark), which is the symbol of Armenia. The graceful movements of the doe are evoked in traditional dance and so the picture is an amalgam of sacred imagery.

5 29 46 **0**		240 178 118	62 21 16 **6**		93 144 162
18 71 65 **3**		200 67 56	48 11 44 **6**		126 171 124
31 59 56 **39**		107 56 49	40 40 58 **29**		109 90 62
72 36 25 **36**		48 75 91	34 13 22 **4**		147 169 163

39 100 75 **0**		156 0 322
11 7 32 **0**		227 227 165
0 42 86 **10**		229 134 27
0 16 67 **7**		236 199 72
40 0 0 **100**		0 0 0

10 70 87 **18**		188 61 19
34 73 82 **55**		75 27 15
8 15 25 **0**		234 211 175
16 24 84 **0**		214 180 41

Directory

Adire African Textiles
London, England
duncan@adire.clara.net
www.adire.clara.net

Raino Annala
Helsinki, Finland
tel: +358102628509
raino@annala.com
www.opaque.tv

Bigert & Bergström
Stockholm, Sweden
tel:+46 8 545 23 230
post@bigertbergstrom.com
www.bigertbergstrom.com

Bishö Design
Mariana Cabral
Guadalajara, Mexico
tel: (+52) 3 641-6953
bisho@bisho.com.mx
www.bisho.com.mx

David Lincoln Brooks
Boerne, Texas
tel: (830) 249-5980
popshott@boernenet.com
www.fabsox.com

Lyle Carbajal
Oakland, California
tel: (510) 536-4450
lylecarbajal@yahoo.com
homepage.mac.com/lyle-
 carbajal/

Zheng Chao
Hangzhou, China
tel/fax: 0086-571-7991944
zc921@yeah.net
zc921.yeah.net

Hyunsook Cho
N. Hollywood, California,
tel: (818) 508-5251
cho56f@earthlink.net

Elmo Aardvark
Will Ryan & Co.
Los Angeles California
Fax: (323) 851-6398

Genevieve L. Esper (Iris)
Port-au-Prince, Haiti
iris@hainet.net
www.action-foundation.com

Mark Fisher
Lowell, Massachusetts
tel: (978) 459-2736
marksfisher@bigplanet.com
www.jupiterjak.com

FlashFonts.com
Los Angeles, California
Leslie Cabarga
tel: (323) 549-0700
lescab@mediaone.net
www.flashfonts.com

Fountain
Mälmo, Sweden
Peter Bruhn
info@fountain.nu
www.fountain.nu

Mark Frauenfelder
Studio City, California
tel: (818) 505-9652
mark@well.com
www. boingboing.net

GDcooya Design
Karachi, Pakistan
Ahsan R. Shami
tel/fax: +92-21-5861787
what@gdcooya.com
www.gdcooya.com

Lorenzo Gonzalez
Arte Maya Tz'utuhil
San Francisco, California
Joseph Johnston, Curator
tel: (415) 282-7654
curator@artemaya.com
www.artemaya.com

Outi Harma
Ten Women Gallery
Santa Monica, California
tel: (310) 314-9152

Rodolfo Hernandez
Havana, Cuba
rodin_12000@yahoo.com

Klan Stockholm
Stockholm, Sweden
Anders Mjöbring
tel: +46 8 50305500
anders.mjobring@klan.se
www.klan.se

Allen X. LeGarreta
Sylmar, California
tel: (818) 438-8713
porterdog@earthlink.net

Magia Comunicaciones
Lima, Peru
Manuel V. Miranda
tel: (511) 221-8553
magia@magiadigital.com
www.magiadigital.com

Main Street
Modena, Italy
tel: +39 59 366626
fax: +39 59 366162
main@mainstreet.it
www.mainstreet.it

Mathius
Punaauia, Tahiti
tel: (689) 822062
fax: (689) 419541
maestro@mathius.org
www.mathius.org

Overvision
Los Angeles, California
Overton Loyd
tel: (213) 687-7233
loydlink@earthlink.net
www.overvision.com

**Pooyesh Nemaad E
Tehran Co.** (Graphics Div.)
Tehran, Iran
contact: Paymaan Jafari
 admin@pooyesh.com
or Maryam Heidari
Maryam@pooyesh.com
www.pooyesh.com/gfx-
design

Ismail Shammout
Amman, Jordan
tel: 5519926,
fax: 5538397
shammout@go.com.jo
www.shammout.com

Signalgrau Designbureau
Essen, Germany
Dirk Uhlenbrock
tel: +49.201.730511
post@signalgrau.com
www.signalgrau.com

S.P.I.R.A.L. FOUNDATION
Pacific Palisades, California
msimcik@sprynet.com
www.spiralfoundation.org
*(A nonprofit group working with
Vietnamese students to develop a
gift line of traditional handicrafts.
All proceeds go directly back to
the students.)*

Pierre Louis Torres
Papeete, Tahiti
torres@wildarsite.com
www.wildartsite.com

Jean Tuttle Illustration
Manchester, Connecticut
tel: (800) 816-0460
jeantuttle@aol.com
www.jeantuttle.com

Vigon Ellis Design
Los Angeles, California
Melissa Hernandez
mh@vigonellis.com
vigonellis.com